CREATIVE
Silk
PAINTING

CREATIVE *Silk* PAINTING

Diane Tuckman & Jan Janas

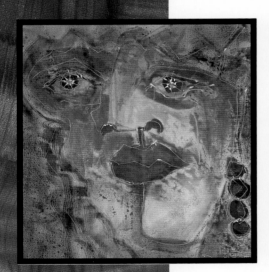

NORTH LIGHT BOOKS
CINCINNATI, OHIO

ACKNOWLEDGMENTS

To my friend Diane for her perseverance.
To my friend Jan for her artistry.

To our editor, photographer, friend,
Bonnie Iris,
for her enthusiastic prodding
in the right direction.

We are thankful for all the silk painters
we have met in our life travels.
They have shared in our dedication
to make silk painting an art form
accessible to all.

This hardcover edition of *Creative Silk Painting* features a ''self-jacket'' that eliminates the need for a separate dust jacket. It provides sturdy protection for your book while it saves paper, trees and energy.

99 98 97 96 95 5 4 3 2 1

Library of Congress Cataloging in Publication Data

Tuckman, Diane
 Creative silk painting by Diane Tuckman and Jan Janas—1st ed.
 p. cm.
 Includes biographical references and index.
 ISBN 0-89134-610-4
 1. Silk painting. 2. Textile painting. 3. Wearable art. I. Janas, Jan. II. Title.
TT851.T832 1995
746.6—dc20 95-1176
 CIP

Edited by Diana Martin
Cover and interior designed by Sandy Conopeotis Kent

The permissions on page 131 constitute an extension of this copyright page.

METRIC CONVERSION CHART

TO CONVERT	TO	MULTIPLY BY
Inches	Centimeters	2.54
Centimeters	Inches	0.4
Feet	Centimeters	30.5
Centimeters	Feet	0.03
Yards	Meters	0.9
Meters	Yards	1.1
Sq. Inches	Sq. Centimeters	6.45
Sq. Centimeters	Sq. Inches	0.16
Sq. Feet	Sq. Meters	0.09
Sq. Meters	Sq. Feet	10.8
Sq. Yards	Sq. Meters	0.8
Sq. Meters	Sq. Yards	1.2
Pounds	Kilograms	0.45
Kilograms	Pounds	2.2
Ounces	Grams	28.4
Grams	Ounces	0.04

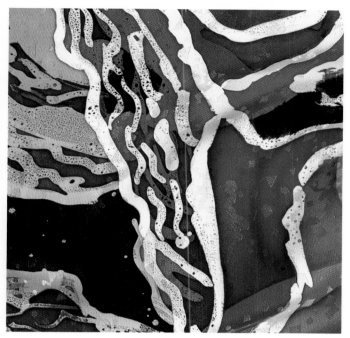

PART ONE

Exploring Instant Set Dyes

Discover the new instant set silk dyes that do not require steam heat or chemical setting.

PART TWO

Creating Creatively

Learn to express your personal vision through silk painting.

JAN JANAS

Born and raised in Chicago, Illinois, Jan Janas pursued her dream of art, studying at Northern Michigan University, the University of Northern Illinois, and the Art Institute of Chicago. She wanted to experience all the art world had to offer, from oil, acrylic and watercolor to ceramics, silversmithing, welding, sculpture and finally, fiber art.

Upon graduating Janas decided to share her knowledge and experience and entered the teaching profession. In 1989 she published her first work on the subject of fiber painting entitled *Janas' Faces*. Pattern books followed and can be found at arts and crafts shops throughout the United States. In 1992 she coauthored *The Complete Book of Silk Painting* with Diane Tuckman of Ivy Imports. Jan's work has been exhibited in galleries and art museums, and her silk wall hangings and exotic one-of-a-kind clothing have been purchased extensively for corporate and private collections.

Jan demonstrates and teaches silk fabric painting across the country, traveling extensively and demonstrating for Ivy Imports, in workshops and on public television. Jan resides in Boulder, Colorado.

DIANE TUCKMAN

Diane Tuckman, nee Yedid, was born in Heliopolis, Egypt. She spent a privileged early childhood learning English, French, Arabic and art at the English Mission School. Nearby Cairo offered the excitement of a modern city richly mingled with the ancient past. Frequent expeditions to the famous Cairo museums, the pyramids, royal tombs and archeological digs were thrilling and inspirational.

Next stop, Paris, France, with visits to the Louvre Museum, exhibits at Le Grand Palais, excursions to Versailles and walks through the woods and countryside around Paris, so delicately depicted by the Impressionist painters. In this romantic setting, Diane met her husband to be, Morton Tuckman. Together they toured France, England, Italy and Austria.

After settling in the United States, Tuckman realized that information and supplies for silk painting were unavailable. She started her ongoing business, Ivy Imports, Inc. The constant search for new and better products led Tuckman to the new instant set dyes used by so many creative silk painters.

Tuckman and Jan Janas, coauthors of *The Complete Book of Silk Painting*, have established a silk painting studio at Ivy Imports in Beltsville, Maryland. They created a comprehensive, in-depth program to train instructors. They also offer "hands-on" silk painting classes on a regular basis in the spacious well-appointed studio. This program brings a diverse stream of beginners, dedicated silk painters and artists from other media to inspire and challenge each other.

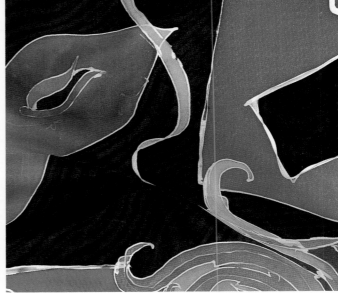

PART THREE

Creating Artistic Attire and Textile Art

Create one-of-a-kind functional art pieces.

PART FOUR

Painting the Kimono: Interpretations

Delight in 23 interpretations of one of the most traditional art forms.

THE SILK ROAD CONTINUES...

As the long silk thread tugs, we are again pulled to explore the magic and challenges of silk painting, a watercolor medium using dyes with "silk" as the painting surface. Since the publication of our first volume, *The Complete Book of Silk Painting*, dramatic changes and growth have taken place. Silk painting has become an established and credible art form in the United States brought about by the large number of talented artists who successfully sell their art. More and more silk paintings are becoming part of museum exhibits, and teaching the art form is included in museum and surface design educational programs.

Initially, direction and inspiration for modern silk painting flowed from France. A large number of French how-to books on the subject helped disseminate information. Silk painting gradually spread to the rest of Europe and other parts of the world. This phenomenon was mirrored in the United States. In the last few years, with the publication of American books on the subject, the vitality of American silk painting has flourished. In typical American style, a "what if" attitude has given impetus to new silk painting techniques. These developments encouraged us to share our innovations to further challenge *all* silk painters.

Silk painting ideas are now flowing across continents, as evidenced by the international work featured in this book. Silk has always been a thread that linked civilizations in commerce and art.

Some of the aspects of silk painting you will find in this volume are old traditional techniques, but they have been updated and used in unconventional ways to create amazing effects. This revitalized approach to silk painting is particularly exciting in view of the new dye products now available. Incredible new ways to paint silk are now possible. This will require experimentation, but it is all part of the satisfying and fulfilling experience of silk painting.

Because of our commitment to the continued vitality and growth of silk painting, we teach and travel, passing along expertise, tips and hints that we have gleaned from the large number of silk painting students we meet. These students often find unusual and smart solutions to problems we did not even know existed!

In the course of our peregrinations, it became apparent to us that there was the need for a silk painting network. The interest expressed by readers of our first book has allowed *The Silkworm* newsletter to become a reality. This is a publication for and by silk painters, and we invite your participation in this newsletter.

Knowing your materials is important to being successful in silk painting, as it is in any art form. By learning the basic techniques—what each silk painting product does and doesn't do and seeing how the medium works—you build a solid foundation that will eventually free you to paint with ease and creativity. All experiences and observations accumulated in the course of your daily life should become part of your own unique development as a silk painter. In short, you must "crawl before you can walk" and "learn all the rules" so you can break them and paint in your own style. By doing that, you will also become familiar with the possibilities as well as the limitations inherent in the art form.

As silk painters, we are committed to the expansion and continued vitality of silk painting. Silk has become the fabric of our existence. So follow us in this adventure as the long silk thread tugs at you, too.

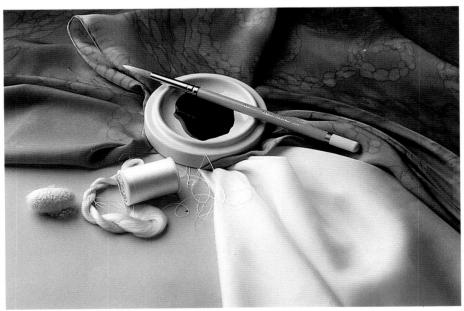

The Silk Road Continues . . . from the silk moth cocoon to the unraveling of the silk filaments that are twisted into a thread that is woven into silk fabric that is hand-painted with silk dye.

Jan Janas, *The Big Bang*, 10mm china silk, 12″ × 12″, instant set dyes and metallic paints, wax paper resist.

One of Janas's students discovered she could use wax paper as a resist instead of the traditional melted wax applied with special tools and removed by dry cleaning.

There was no plan in the creation of this piece. Janas took a random spraying approach, using old stencils she happened to have on hand, to see what kind of design would result. When she stood back and looked at her work, she saw all these caricatures. Rather than have the dye color dominate the scene by painting in the caricatures, she brought them out more graphically with a black marker. Since Janas knew how to use her materials, she got beyond them . . . for an excellent result. She was not silk painting; she was *creating*!

Jan Janas, *Dream Scene*, (detail), 8mm china silk, 10″ × 36″, instant set dyes and permanent black marking pen.

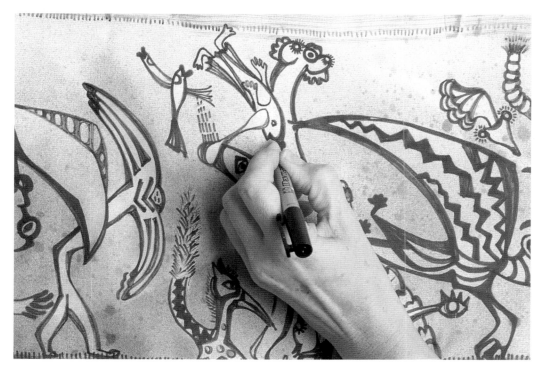

BASIC TOOLS AND SUPPLIES

Your silk painting tools, supplies and workspace can be as flexible as the medium itself. Adapt the workspace to your particular situation and your creative needs. Some silk painters work on a card table with the supplies in a box underneath, while others, lucky dogs, have a completely furnished studio. Even the tools and supplies should be adapted to your particular situation. You can purchase tools and supplies at an art store, craft shop or by mail order. We also found the most useful tools in the drugstore and the most unusual ones in the painting section of the hardware store. No possibility should escape your scrutiny. Make your own supply list from the suggestions below to help you get started in silk painting. To start small, begin with a dye kit, one brush, and a small piece of fabric. Enlarge your tool chest as your confidence grows.

THE DYES

See page 23 for information about flowable and nonflowable dyes.

THE CATALYST

A catalyst is a chemical added to distilled water and used to prepare fabric for painting and to dilute instant set dyes. See page 18 for an in-depth explanation of using the catalyst.

PREWASH

A commercial textile prewash (e.g., Synthrapol or Tanager) or water and mild soap removes sizing, grease and dirt which can interfere with the dyeing process.

SHAMPOOS

Neutral shampoos, such as baby shampoo, Milsoft or Visionart silk shampoo, combined with one tablespoon of white vinegar, condition the silk and improve the hand of the fabric.

THICKENER

Sodium alginate (a powder mixed with water) thickens the dyes for direct painting, silkscreening, block printing or monoprinting.

FABRICS

Dyes behave differently with silks of varying weights and weaves, so purchase an assortment of white silks. First try 5 momme or 8 momme china silk, then experiment with heavier weights. The instant set dyes are also effective on wool, so try a lightweight wool challis first.

There are many types and weights of silks available. This boxful of unpainted silk is just waiting to be painted.

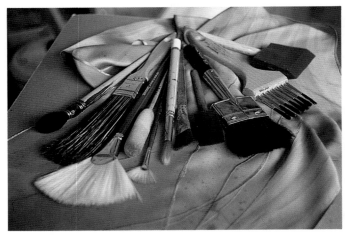

Having on hand an assortment of brushes makes silk painting an exciting adventure.

Use a different sprayer for each color dye. Always wear a mask.

PAINTING SUPPORTS

Dyes can be painted with the fabric flat or suspended. To work flat, place the fabric on plastic tablecloths, Plexiglas, Formica, trash bags, floor covers, and similar liquid-repellant items.

To suspend silk, you will need a frame (canvas stretcher strips, embroidery hoop, lumber and C-clamps), pushpins, and a table large enough to hold the frame. See pages 53-55 for more information on stabilizing fabric.

BRUSHES

The two most useful brushes to have on hand are the medium-sized pointed round and the 1-inch foam. But try to collect a variety of natural hair or synthetic filament brushes that will let you create a range of effects.

SPRAYERS

Since the consistency of liquid dyes is conducive to spraying, you can use fine mist sprayers, atomizers or an airbrush.

STENCILS

Quick repeats with thickened liquid dyes are easy with precut or handmade stencils. To cut your own designs, use Mylar, stencil paper, or nonabsorbent heavy paper and a sharp cutting tool. Be flexible; try tape, leaves or a cheese grater as alternatives for block outs.

STAMPS

Another quick and easy way to repeat a shape is to use premade stamps or cut your own using a potato, art-gum eraser, sponges, linoleum block, etc. Stamping works best when dyes are thickened and/or when fabric is stabilized.

RESISTS

Resists are used as a blocking agent on fabric and for outlining pattern pieces when you are planning to sew a garment from painted yardage. A wide variety of resists exist. See pages 21, 31 and 60-67 for more information about resists.

RESIST APPLICATORS

Resist applicators include squeeze bottles with or without metal tip, paper cone (similar to a cake decorating tool), brushes and tjanting tools. For a more creative approach, try sponges, syringes or toothbrushes.

CONTAINERS

Silk painting always seems to create the need for a wide variety of storage containers for the dyes. You will need a dozen or so clear plastic cups for color mixing; large and small containers for rinsing brushes, dipping small pieces of silk and storage of dyes; white plastic buckets for dip-dyeing and rinsing yardage; and a welled palette and ½-ounce plastic cups for painting with the thickened or liquid dyes. Don't use metal or aluminum containers, which can affect the instant set dyes.

TEXTURING TOOLS

The most amazing effects can be achieved very simply with texturizing tools. The challenge is recognizing the tools and realizing their potential. Try cotton swabs, sponges, plastic shapes, brayers, wads of wax paper, plastic wrap, blackboard erasers, straws, toothpicks or empty refillable markers.

Keep a portfolio of the stencils you've made. It's amazing how useful they are for layered effects.

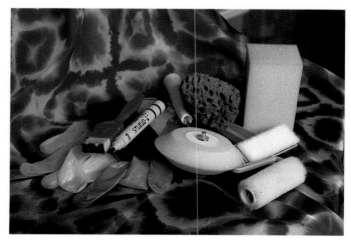

Anything goes in silk painting. You'd be surprised how many texturizing tools you can find when you look around you.

PART ONE

Exploring Instant Set Dyes

ABOUT TRADITIONAL DYES

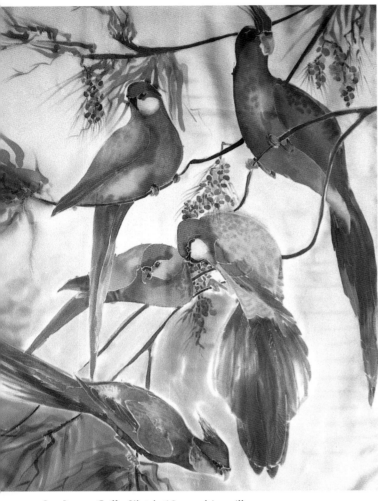

Jan Janas, *Coffee Klatch,* 10mm china silk banner, lined, 48" × 36", French acid dyes.

These realistically painted, brightly colored birds were done with a combination of resists, blends and water-spotting techniques. The background was created wet-on-wet to add depth, and the leaves and berries were drybrushed with quick, loose strokes.

Imagine the potential of silk painting: exquisite works of art, luminous colors, soft-draping fabrics. What a combination! But where do you start? Whether you are a beginner or an experienced silk painter, an important starting point is a central player in the mystery: dyes.

Silk painting is the direct application of dyes to fabric. Like watercolor, silk painting uses transparent colors and no white, just the white of the fabric. An important feature of silk painting is that the dyes flow over and through the fibers of the fabric. You can use many different types of dye: acid, reactive, vat, instant set or liquid paints. We have used and continue to use some of them. You may wish to research the characteristics of these various products and select the one or ones that best suit your needs.

Due to the dramatic way the new instant set dyes increased our own silk painting repertoire and enhanced our creativity and due to the paucity of information about them, we will explain their characteristics in depth in this section. We encourage you to explore the traditional dyes, too, and recommend our first book, *The Complete Book of Silk Painting,* as one source of information.

WORDS OF ADVICE AND CAUTION

The art materials market has been changing radically in recent years. Chemical dyes that have been around for years can suddenly change drastically or disappear from the market. As some chemicals become unavailable, they are replaced by others, requiring the reformulation of certain colors within a product line. Other changes are the result of health and environmental concerns and laws regulating some products. Due to these factors, changes are constantly being introduced by manufacturers. You should therefore continue to keep abreast of these changes and remain flexible.

Be aware of the particular hazards involved with any dye. Read the labels. If you want more information, contact the manufacturer. As an occasional silk painter, follow the precautions indicated and use your common sense. If, on the other hand, you paint several hours or more every day, you must take better precautions. Install an exhaust fan, wear a mask when required, and use gloves to avoid skin contact. Dispose of your dyes responsibly, and follow the rules in your community.

TYPES OF DYES

- **ACID OR FRENCH TRADITIONAL SILK DYES:** These contain soluble colorants in a solution of water, alcohol and acetic acid. They are considered a fugitive dye until steam set for an hour or more. They should be used only on protein fibers, silk, wool, hair (dog, rabbit, camel, etc.), and man-made protein fibers, such as nylon.
- **FIBER REACTIVE DYES:** These dyes come in liquid or powdered form and are mixed with salt or urea and washing soda. They dye cellulose and protein fibers and require a final chemical bath or steam setting to chemically bond colorants with fiber molecules.

- **LIQUID VAT DYES:** Vat dyes are light sensitive. To create the color, the dyes must be developed in ultraviolet light (sunlight or artificial). They require no heat setting to make them permanent and can dye cotton, linen and rayon.
- **INSTANT SET DYES:** The instant set dyes chemically bond instantly to protein fibers and do not require steam, heat or chemical setting.
- **LIQUID SILK PAINTS:** Liquid colors are composed of a pigment base highly dispersed in a water solution and acrylic resin. They require heat setting with an iron and work on all fabrics.

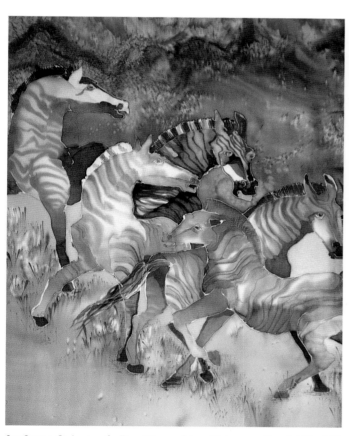

Jan Janas, *Stripes on the Run*, 10mm china silk banner, lined, 48" × 36", liquid silk paints.

The zebras were resisted wet-on-wet to get the repeated stripes. While the background was still wet, Janas applied salt heavily to the mountains and sky to create a lot of texture. Less salt was applied to the foreground. Then she drybrushed the grasses. The overlapping shapes and unconventional colors of the zebras add unexpected excitement to the work.

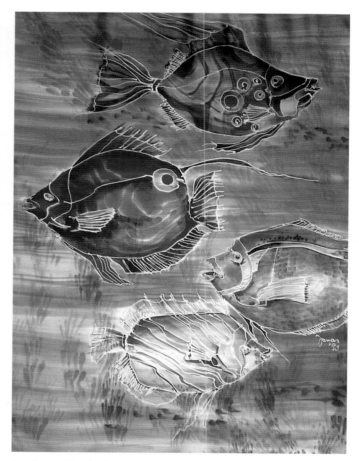

Jan Janas, *Two by Two*, 10mm china silk banner, lined, 48" × 36", instant set dyes.

The fish were resisted, then light stripes in the background were painted, then overdyed with pale blue. Brush marks were stroked to texture the fish and seaweed. The colors were layered gradually to reach the final vivid, intense color.

INSTANT SET SILK DYES

When the instant set silk dyes from Switzerland came to our attention we were intrigued as we watched Swiss artists use them. The potential for their application to silk painting was evident, but the cursory German-language instructions that came with them were incomplete. We discovered that *instant set* means just that: these dyes bond to the fabric without any setting process to make them permanent. *No steam, heat or chemical setting is required.* These dyes are self-setting and immediately become an integral part of the fabric. How easy and what a time-saver!

When we tried the dyes, we were initially turned off. They did not *flow* like traditional silk dyes! The colors were too bright for us, and layering them sometimes led to dull color. We could not get them to do what we wanted them to do! It took a lot of introspection as well as trial and error for us to understand the product. What we discovered was that we were trying to make them behave like steam set acid dyes. Once we overcame this prejudice, we were able to make them work and we gained something: an instant set dye with no setting process.

But we also lost something: the easy flow of the dyes. However, we are now able to compensate for the loss of fluidity by taking advantage of the moisture level on the surface of the silk and in the brush. This evolved into new approaches to old techniques, which will be explored later in this book.

The instant set dyes are easy to use and nontoxic. They are concentrated and *must* be diluted with distilled water or a catalyst diluting solution. No measuring or mixing with any other chemicals is required.

Due to the unusual properties of instant dyes, they can be painted with the fabric flat or stretched. When painted flat, the fabric is placed on a plastic-covered table, and the painting approach differs from stretched silk (see page 52). In addition to small projects, these dyes are well suited to the production of large brilliant silk paintings and yardage and for immersion dyeing of yardage.

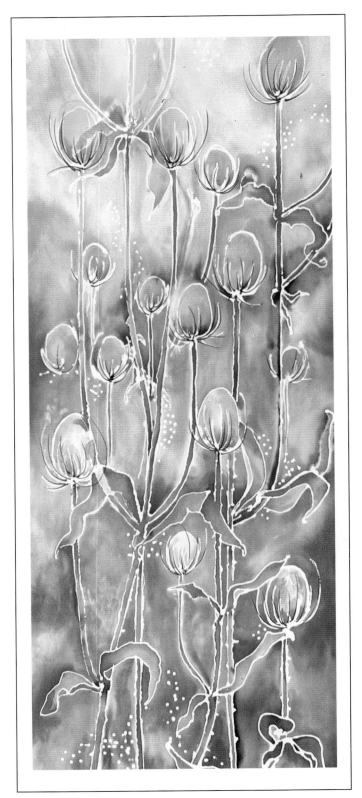

L. Maxine Kurtzbein (Camas, WA), *Teasel*, 10mm china silk, 13" × 36", instant set dyes, gutta resist, fabric pen embellishment.

Kurtzbein's soft blending of background colors gives a wonderful depth to this floral composition. Notice the strong linear and rhythmic qualities of the resisted foreground. This teasel looks as if it was reaching up to the sun on a balmy fall day.

Properties of Instant Set Silk Dyes

The instant set dyes, available in stores and by mail order, offer a unique approach to silk painting because of their immediate reaction with silk fibers. These dyes consist of highly reactive molecules that have a particular affinity for silk. As soon as the chemical dye molecules come into contact with the receptor molecules of the silk filament, a chemical reaction takes place. The dye and the silk bond *permanently*. The dye molecules that do not adhere to the silk remain suspended until they are rinsed away.

If the fabric is overloaded with dye, that is, too concentrated, the excess will transfer to other sections of the silk when rinsed. This is called *dye-back*. However, if the dyes have been sufficiently diluted and applied correctly, there will be no dye-back and the water will be clear after rinsing.

DILUTING THE DYES

The instant set dye colors are transparent, bright, clear, intense, and they intermix well. They are concentrated and must be diluted for best results. When undiluted they are too heavy to be easily absorbed in the fabric. The ratio of dilution is determined by how many dye molecules are necessary to fill the receptors on a particular weight of silk and the intensity of the color desired. Since every situation is different, you will have to experiment and create your own diluting chart based on the weight and type of silk you are using and your own color choices. We have found some colors to be more concentrated than others, so dilution varies from color to color.

CONTROLLING THE COLOR

The best way to control the dyes is by diluting and layering the color. Since the dyes bond instantly to the silk, it is important to begin painting light over light and build up to darker values and colors until you obtain the right hue and value, as you would using watercolor on paper.

CHOOSING THE RIGHT FIBER

Instant set dyes are most compatible with protein fibers, such as silk (bonding is instantaneous) and wool (bonding can take up to an hour). Man-made fibers, such as rayon and nylon, which mimic the characteristics of silk, do not work as well with instant set dyes. The dyes bond slower on these fabrics, the colors are duller, and the washfastness is not reliable. We do not recommend them for these fabrics at this time. Instant set dyes do not work on cotton or polyester.

PREPARING THE CATALYST DILUTING SOLUTION

The catalyst made by the dye manufacturer is a chemical that softens the water and prepares the fabric to better interact with the dyes. Use this solution to dilute your dyes as well as to prewet your fabric so it interacts better with the dyes. The catalyst is a concentrate, so add one teaspoon of catalyst per gallon of distilled water. (Tap water may contain contaminants that could affect the dyes.) This catalyst solution will not spoil, so feel free to make it in large quantities. For smaller quantities, use just a few drops. Too much catalyst in the solution or undiluted catalyst prevents the dyes from bonding to the silk.

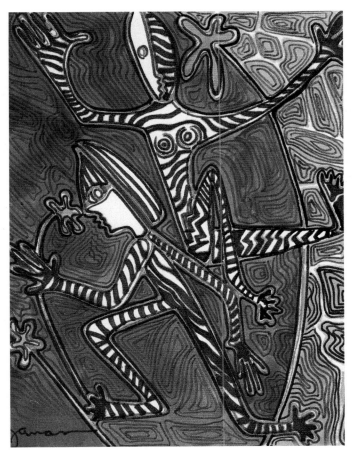

Jan Janas, *Lizard People*, 10mm china silk, 9" × 10", instant set dyes.

Because instant set dyes bond immediately to the silk fibers, Janas was able to adhere the silk to an adhesive board, paint directly and frame it. No fixing, no steaming, no fuss. Just plain create!

CONTROLLING THE BONDING TIME

Even though the instant set dyes bond within seconds, you use the catalyst to speed up the bonding time by approximately 20 percent. The result, though, is less time to work the dyes. Here are several ways to counteract this rapid action:

- Use only distilled water to dilute the dyes. Then paint on dry silk. This method is great for textural effects.
- Prewet the silk with distilled water only, and use distilled water (no catalyst) to dilute the dyes. The distilled water will oversaturate the fiber, leaving no room for the dye to bond. As a result, until that water evaporates, you have time to move the color around on top of the wet silk (hydroplaning) to your satisfaction. This gives you a watercolor look.
- Prewet the silk with the catalyst diluting solution, but use dyes that have been diluted with water only. Again, the dyes will hydroplane, slowing the bonding time. This also results in a watercolor look but reduces streaking. To get a very smooth, unstreaked coating of color, saturate your silk fibers with catalyst solution before painting.

Knowing the subtle effects of each of these methods—dilution with or without catalyst and prewetting the fabric—will make a significant difference in the manipulation of the instant set dyes and the look of your fabric. To control the dyes and obtain a watercolor look, you must understand the diluting principles described above.

LIGHTFASTNESS

The lightfastness of the instant set dyes is good, although exposure to continuous sunlight will cause the dyes to fade. To improve the lightfastness, consider using a silk shampoo that contains a sunblocking agent that protects the silk from ultraviolet rays.

SHELF LIFE

Instant set dyes have a shelf life of two years or more if unopened and not contaminated by bacteria in the air, trace elements in the water, and containers and brushes that are unclean. Opened and uncontaminated dyes will last from months to two years. Opened and contaminated dyes will last from days to weeks depending on conditions. You can visually tell that a dye color has expired because the color will turn a watery gray in the bottle.

CONTROLLING COLOR

STEP 1. Instant set dyes handle just like watercolor. You can begin by lightly sketching in your design on the silk. Then paint directly, in light colors, and mass in the base color.

STEP 2. Since the dyes bond instantly to silk, it is important to gradually layer the dyes, adding more detail and darker color as you work.

STEP 3. Add more definition with a black permanent marker.

Jenni Ottens
(Netherlands),
Summer, 50 × 70
cm.

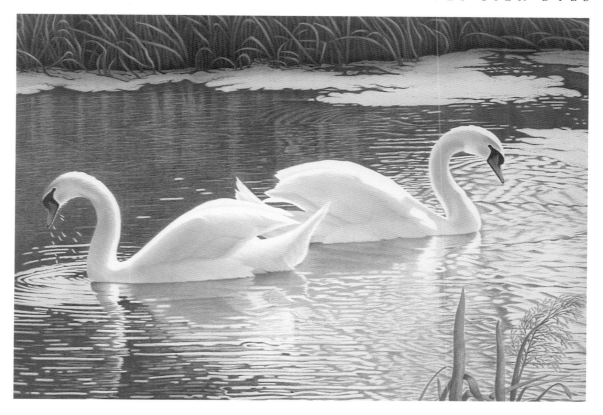

COMPATIBILITY WITH OTHER DYES

Because of their unusual properties, avoid mixing instant set dyes with other types of dyes in the same container. However, different dyes can be *layered* on the same piece of silk. Imagine all the possibilities for quick touch-ups, fill-ins, or doing the background first or last! These additions or corrections need no setting. As they say in France, "Quelle trouvaille" (What a find)!

CLEANUP

To clean up your work area, add two tablespoons of rubbing alcohol to a 24-ounce spray bottle filled with water. This solution is great for removing dirt, grease and excess dye from your work surface. If you get dye on your hands, use one of the special hand cleaners for dyers, or first wipe off the stains with alcohol and then wash with soap and water. Clean brushes and applicators with water and soap and a final rinse with the water-alcohol solution.

TIPS FOR THE CARE OF YOUR DYES

To keep the colors bright and pure, here are a few tips and hints:

- Never put a brush into a bottle of dye.
- Keep your brushes clean.
- Keep the original bottles capped when not in use.
- Use distilled water, not tap water, when mixing and diluting.
- Never pour mixed or diluted dyes back into the original bottles.
- After mixing and diluting, pour the leftover dyes into glass jars with plastic lids or PET rigid plastic storage bottles.
- Store all containers in a cool dark place.

CONQUERING THE FOUR BIG SNAGS

When we started working with the instant set dyes, we discovered that we hit a snag every time we went around the corner. We undertook solving these snags by getting to know the unusual properties of these dyes, seeing how they work, and using that knowledge to our advantage.

Normally, traditional silk fabric dyes flow quickly on the fabric through a process known as capillary action. In general, when dyes are applied to silk, they move and travel as the moisture carries the dyes. Dyes that are in a liquid state, saturate the silk and keep moving until there is no more moisture. It can best be described as wicking or bleeding on the fabric. Silk, because of its natural ability to absorb liquids, is particularly susceptible to that phenomenon. The level of moisture on the fabric determines the capillary action or lack thereof. This capillary action takes place in various forms.

The capillary action of the instant set silk dyes can be affected by the following factors: moisture on the fabric, liquid content of the brush, pressure on the brush (which determines how much dye is released), and length of time the brush remains on the silk (which affects the color intensity, amount of dye released, and amount of moisture picked up

from the brush). The level of spreading is also greatly affected by the placement of one color over another. For example, usually after the fabric is dip-dyed or painted with a color, there will be much less capillary action when the second color is applied.

Snag No. 1: The "No Flow"

The first snag is that instant set dyes *do not* flow continuously because of the constant bonding action! When we started working with the instant set dyes, we discovered that they did not appear to flow and that we could not manipulate them.

We resolved this snag when we found out the only way to obtain dye movement was by controlling the amount of liquid color on the brush and moisture on the silk. When the brush is *loaded* with diluted color and the fabric has been prewet, you can achieve the effect of the flowing dyes. Otherwise the dyes *bond continuously as you paint*. You can achieve the best control of the dyes when the silk is at a critical level of dampness: neither too wet nor too dry. You are trying to adjust to the low, slow flow of these dyes. Just as we did, you need to overcome the shock that once the dye is painted on the silk *it will not move*. Use the information above to manipulate the dyes to your satisfaction.

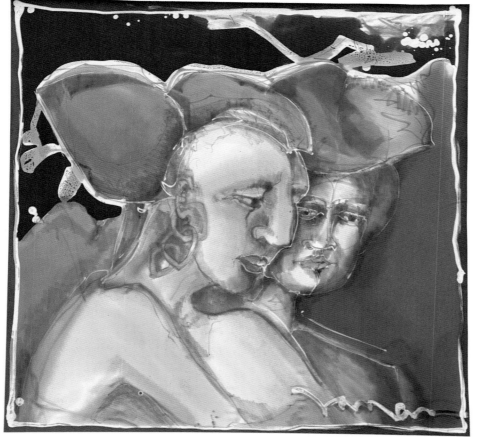

Jan Janas, *The Big Question*, silk broadcloth, 45" × 45", French acid dyes.

Janas's knowledge of the properties of instant set dyes versus traditional silk dyes helped her make good decisions on painting *The Big Question*. She selected traditional French dyes because of her mood and the mood she wanted to project: She wanted to be able to manipulate the colors in a flowing way. She wanted to have large, flat, heavy-duty black and red areas. This is very hard to do with instant set dyes on a heavy fabric, unless you dip-dye, and Janas didn't want to do that. So she chose the longer, slower approach, the traditional approach. Knowledge gives you real choices.

Jan Janas, *Hard Edge*, 8mm flat crêpe silk scarf.

This scarf shows the advantageous effect of capillary action, that is, the wicking or bleeding properties of the fabric as it reacts to the traditional silk dyes. Water-spotting and hard-edged lines can only be achieved with traditional liquid dyes when they're in the unset state. Instant dyes set too fast.

Snag No. 2: Halo

Instant set silk dyes sometimes create a faint halo around a painted area. It looks like a water mark around the dye, which has so quickly and effectively bonded to the silk. We discovered that as the bonding takes place, the dye is spent. The fabric cannot "grab" any more color, and the vehicle for the dyes, which we call "chemical water," continues to creep on the fabric and eventually stops and creates a halo. This doesn't happen when the surrounding area is resisted, only when there is dry space around the dye.

As we painted other colors over the halo, we discovered that the creeping chemical water had stained the silk and caused a change in the color of the dye layered over it. Our solution was to brush clear water over the dye and halo before we continued painting with another color. Since the instant set dye color you apply will not smudge, you can brush the water over the color and through the halo, essentially washing the chemical water to the edge of the silk. After it dries, the halo disappears, and you can continue painting.

Jan Janas, *Bouquet*, 8mm china silk, 10" × 10", instant set dyes.

By controlling the amount of liquid on the brush, you can create a certain amount of movement of instant set dyes on the silk. There was more liquid on the brush when painting the flowers and less when painting the leaves, so you get a hard and a soft look.

Jan Janas, *Bouquet too*, 8mm china silk, 10" × 10", instant set dyes.

Even though instant set dyes don't flow well enough to have full capillary action, to create crisp definition between shapes, use a resist (see page 3). Be aware of the amount of liquid color in your brush, especially when you want flat areas of color. Notice the many areas in this piece that are mottled because the moisture level on the brush and fabric was too low.

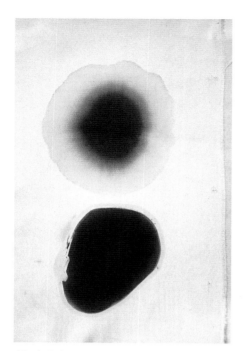

(Top) Color separation only occurs when there is a large enough white, unpainted silk area around the wet dye. The upper circle shows the result of color separation when a cool black instant set dye was applied to dry silk. The capillary action separates the color components of the dye. (Bottom) On the other hand, when the color butts up against a resist or another color, there is no room for color separation to occur, and a solid color results.

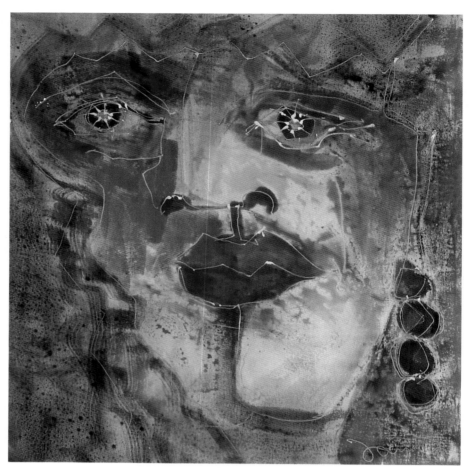

Jan Janas, *Judy*, 8mm china silk, 22″ × 22″, instant set dyes and metallic paints.

Because instant set dyes bond instantly, too much layering in one area can create dead color: color that gets too neutral because the life (brilliance and intensity) has gone out of it. Here you see red, yellow and turquoise blended successfully on the right side of the face, but on the left, the colors turned a dull violet.

Snag No. 3: Color Separation

Another interesting halo effect takes place when certain colors—mauve, brown, gold-brown, gray, cool black, and warm black—break down as they flow into areas of dry unpainted white silk. The components of these colors separate to form interesting colored halos around the original color. We initially considered this just one more snag until we discovered that it only happens when the area is not resisted and the silk is dry. We now use this effect for subtle gradations between repeats of the same color. The results can be compared to "double loading" your brush, which is when you load your brush with one color and then with a second color before you paint.

Snag No. 4: Dead Color Spots

The final snag was that, for no apparent reason, areas of dead color appeared in our paintings. Can you imagine happily painting with brilliant colors, and then all of a sudden seeing a dark dull blob appear on the silk? It was infuriating. This dark area could not be removed. It was bonded. We had never before encountered such a situation.

Most other dyes can be continuously blended when the colors are unset and superimposed. Once set, the colors return to the intensity they had when wet. But with the instant set dyes, the colors are set as they are painted, and they dry two values lighter. So that was the key. Again, we had tripped ourselves by attempting to make the instant set dyes behave like steam-set dyes.

We analyzed the situation and discovered that dark, dead spots arose when multiple layers of colors were superimposed. With steam-set dyes, this would produce a single color. With the instant dyes, because they're constantly bonding, you get a distortion of the color. They don't blend on the fabric; they just lie on top of each other, which sometimes results in dead color.

As you work with instant set dyes, you may come across other snags. Be flexible, try to understand why the problem is occurring, and network with other silk painters for solutions. Look for creative ways to turn this snag to your advantage. Don't see it as a snag. See it as a chance to discover another technique!

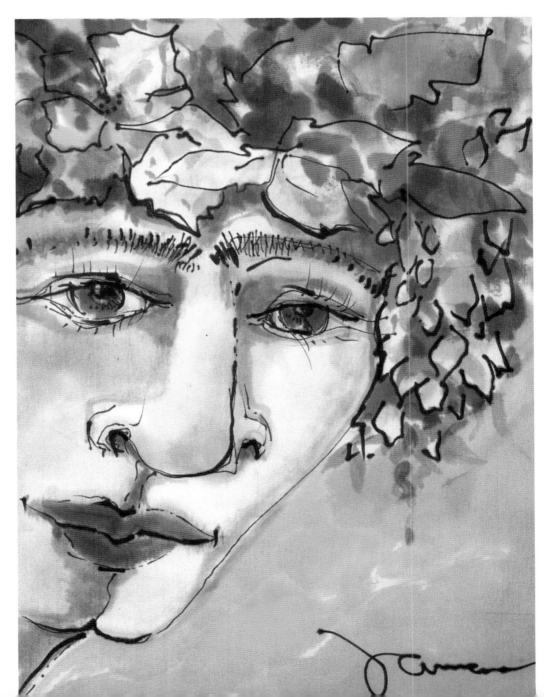

Jan Janas, *Bacchus*, 8mm china silk, 9" × 10", instant set dyes.

Here Janas has used a snag as a tool for creating neutral color areas. She deliberately placed dead color above and below the mouth, under the hair and as eye shadow where neutral color would normally be found.

PAINTING WITH THE NEW DYES

In working with the new instant set dyes, always keep in mind the major difference between these dyes and traditional silk painting dyes: They do not flow, although they can be made to flow slowly (see page 23). Use this outline as a guide when planning a project. Make your major decisions first, then proceed to the next stage.

MAKE SOME DECISIONS

1. Decide whether you will stretch the fabric.
2. Decide whether you will use a resist.
3. Plan your design and color scheme.
4. Select the most appropriate fabric.
5. Select technique(s) from those described on pages 19-31.

PREPARATION: WORK SURFACE AND DYES

STEP 1. Fill a spray bottle with distilled water and two tablespoons of rubbing alcohol.

STEP 2. Fill a second spray bottle with the water/catalyst solution (see page 3) or plain distilled water. (The second sprayer is used to wet down the fabric when you are working flat.)

STEP 3. Spray your work surface with the alcohol solution and wipe with a paper towel to remove grease, dirt or dye residue.

STEP 4. Dilute your dyes and test them on fabric strips to be sure you have obtained the correct values for the type of silk you are using. When the silk dries, you will see the true value of the color. (It appears brighter when wet.)

STEP 5. To see if you have diluted your colors sufficiently, lift the silk. Your work surface should be free of dye (meaning that all the dye has bonded to the fabric). If dye is on the work surface, dilute the dye further. You can also check for proper dye dilution by pressing a scrap of wet white silk onto the test fabric; no color should transfer. Finally, rinse the fabric; the water should run clear.

PREPARATION: FABRIC

STEP 1. It is recommended that you prewash your silk, particularly if you are working on an important piece.

STEP 2. When working flat, spread the silk on a clean worktable.

STEP 3. If you plan to work wet-on-wet, mist the silk lightly (optional) with water or the water/catalyst solution.

STEP 4. Smooth the silk from the center toward the edges, using your fingers, brayer, roller or foam brush, until the silk clings to the work surface. Smooth the silk completely flat, or leave some bubbles, folds or other irregularities to create special effects. You can paint the silk without prewetting, though it is more difficult to keep the silk flat.

STEP 5. When using a resist (see page 3), it is preferable to work on stretched silk (see page 52). Stretch the silk and outline the design with the resist and resist applicator (see page 3) you have selected.

PREPARATION: PAINTING TOOLS

STEP 1. Choose from a variety of tools to apply the dye (see page 3).

STEP 2. If you use a brush (see page 3) to apply the dye, it is easier to use a different brush for each color when painting with the instant set dyes. Do not overload your brush unless you want to create a smooth blend.

PAINTING

STEP 1. Decide if you want to paint the silk when it is wet, damp or dry. Each choice produces a different effect. When painting on wet silk, you can obtain a more fluid look. When it is damp, you have the best control. When it is dry, the dyes will migrate slower and in a more uneven manner. In general, for best results, blend your colors very quickly because they react to the fabric extremely fast, even when wet.

STEP 2. As you paint, refer to your design and color scheme notes, but allow yourself to be flexible and make changes, if appropriate.

STEP 3. Since the dye will not migrate on the silk when you're using resist, you need to move the dyes more forcefully toward that line.

RINSING

STEP 1. After completing your painting, rinse your fabric to remove any excess dye.

STEP 2. Rinse fabric (individually, if multiple pieces) in *cold water*. Rinse well until *all* excess dye has been rinsed out. If too much dye has been used, first rinse very quickly in cold water for three seconds, then plunge the silk again in clean, cold water.

STEP 3. For the final rinse, combine a small amount of a neutral shampoo and white vinegar to the water. Follow these general guidelines: Never soak painted fabrics, *use only cold water*, use only neutral shampoos, avoid chlorinated or alkaline water, use catalyst to improve bondability. Avoid frequent washing.

WASHING: FABRIC CARE

STEP 1. Hand wash (or dry-clean) your painted fabric. Don't use harsh detergents or soaps, benzine-based products or stain removers. Careful washing of your silk adds shine and life to the fibers and improves the hand.

STEP 2. After washing, roll the silk in a towel and squeeze gently (do not wring) to remove excess moisture.

STEP 3. Iron immediately or while still damp with a dry iron set on "wool." If you choose to hang the silk while wet, do not hang it on rope, wire or untreated wood because the dyes stain. Use plastic or treated wood instead.

RESISTS

Resists are used as a blocking agent on fabric, usually for outlining a shape or area. A resist prevents dye from saturating a particular part of the fabric. Traditional resists for silk painting are solvent-based gutta resists, water-based resists and wax. The first two types of resists are available clear, colored or metallic. For a more contemporary approach to resisting, try rice pastel (available in specialty stores, such as Japanese katazome suppliers), wallpaper paste, clamps, string, rubber bands, water soluble glue, sodium alginate (mix one part powder and five parts water), and sugar syrup (use equal parts sugar and water, boil until thickened and reduce by half). Base your choice upon the look you seek.

The tool you use to apply the resist will influence the look of your artwork. Traditional resist applicators are a squeeze bottle with or without a metal tip, a paper cone (similar to a cake decorating tool), a brush or a tjanting tool (a traditional Japanese batik tool). For a more creative approach, try sponges, syringes, a toothbrush or your hand.

For more information about resists and their application, see *The Complete Book of Silk Painting*.

Answers to the Most-Asked Questions About the New Dyes

WHAT DOES "INSTANT SET" REALLY MEAN?

It means the dyes bond to the silk permanently and *instantly*, within seconds. The bonding time is longer for wool, about one hour.

WHAT METHOD IS USED TO SET THESE DYES SO THE FABRIC CAN BE WASHED AND DRY-CLEANED?

Absolutely none. No steam setting, heat setting or chemical setting is required. Although the fabrics are washable and dry-cleanable, like all hand-painted silks, frequent washing and dry cleaning is not recommended.

WHAT CHEMICALS DO I NEED TO MIX THESE DYES WITH TO MAKE THEM WORK?

Only water and/or catalyst.

WHY SHOULD I USE THE CATALYST?

The catalyst, when added to distilled water, dilutes the instant set silk dyes. It controls streaking of colors and reduces dye-back. It also speeds up and enhances the bonding of the dyes to the silk by approximately 20 percent.

WHY USE SILK SHAMPOOS?

Silk shampoos help reduce dye-back, improve the hand, and condition the dyed silk.

ARE THESE DYES NONTOXIC?

They have been graded as nontoxic and conform to ASTM 4238. Nevertheless, take the same precautions you would with all chemical dyes. Wear gloves to avoid dye-stained hands and wear a dust mask when spraying.

HOW LONG DO THE INSTANT SET DYES KEEP?

The new dyes have an excellent shelf life, except for the color olive. Unopened, they last up to two years. Opened and uncontaminated, several months to two years. Opened and contaminated by things such as bacteria, only a few weeks to several months. Uncontaminated colors diluted with the catalyst solution will keep for months.

CAN I USE WATER ONLY IF NECESSARY TO DILUTE THE DYES?

Yes. Read the answer to "Why should I use the catalyst?" before making this decision. Without the catalyst, the colors won't bond as fast and as well, but it is often done. Use distilled water.

DO SALT AND SPOTTING TECHNIQUES WORK?

No, because the dyes *bond instantly.*

CAN I PAINT PRECONSTRUCTED GARMENTS?

Indeed, the instant set dyes are *excellent* for preconstructed garments because there is no requirement to stretch or set the fabric. Embellish portions of the garment by direct painting, and/or dyeing the entire garment by immersion in a dyebath.

CAN I USE THESE DYES WITH OTHER TYPES OF DYES THAT REQUIRE SETTING?

Yes. They can be used with other dyes for enhancement and overdyeing. *Do not intermix different dyes in the same container.*

HOW CAN I DEEPEN THE COLORS IF THEY'RE TOO LIGHT?

By layering them. When mixing, avoid using black to deepen the colors. It usually dulls them.

HOW BLACK IS THE BLACK AND HOW RED IS THE RED?

To get a deep dark black, thicken the dye with thickener, such as sodium alginate. The red is on the pink side. To get a lipstick red, add some fuchsia and yellow.

WHY DIDN'T THE DYE PENETRATE TO THE OTHER SIDE OF MY SILK?

You're probably painting on heavy silk. Because the dyes bond instantly to the silk, they don't have time to penetrate to the other side if the fabric is heavy.

TEN TECHNIQUES FOR THE NEW DYES

Techniques for flowable dyes (e.g., French dyes) and paints can be adapted for use with nonflowable dyes (e.g., instant set dyes) for expressive styles of painting. By trying these techniques with instant dyes, you will see how differently these new dyes behave on silk compared to traditional approaches, so you can learn to control them and try more involved techniques. Before plunging into practicing these techniques, you would be wise to review the sections on the new dyes (pages 8-11) and pages 2-3, which describe the tools and supplies used for these techniques. Also, *The Complete Book of Silk Painting* can provide additional information.

To "get a handle" on how these dyes work, approach each technique systematically. Cut several squares of silk, about 10" × 10", and experiment. Keep detailed notes and attach them to each sample. You'll find that you will frequently refer to these samples for ideas and to review your discoveries. Above all, keep an open mind and a sense of adventure!

The techniques described in this section are the basis for your "bag of tricks" with the instant set silk dyes. You will quickly get caught up in the excitement of working with them. The combinations are endless! You can create amazing effects with the instant set silk dyes in combination with other products. Look to the chapter on advanced techniques for even more creative ideas.

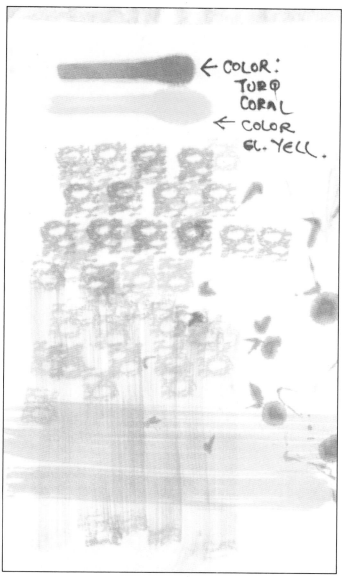

Use a black permanent marker to write detailed notes directly onto your silk for future reference.

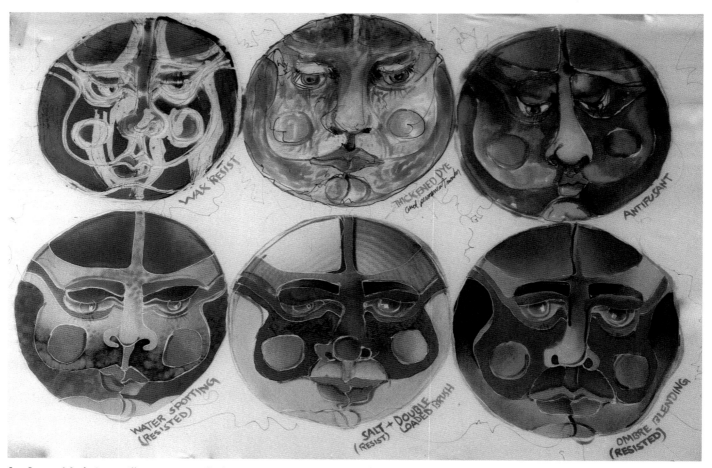

Jan Janas, *Mask*, 8mm silk, steam-set silk dyes.

EXERCISE: one design, same colors, repeated six times.
OBJECTIVE: to demonstrate how the diversity of techniques can richly affect the same design.

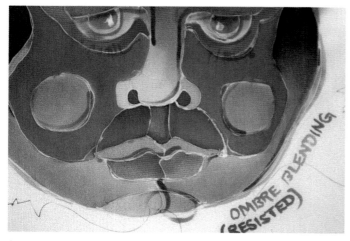

Jan Janas, *Mask* (detail).

BLENDING.
After resisting, the flowable dyes were blended to create a delicate ombre effect.

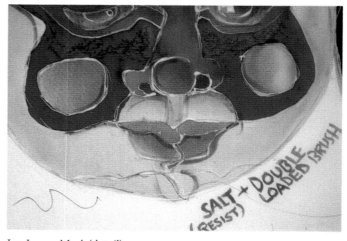

Jan Janas, *Mask* (detail).

SALT.
The easy salt technique produced the distinctive textural effect on either side of the nose. This technique works only when the flowable dye is wet. Salting does not work with instant set dyes.

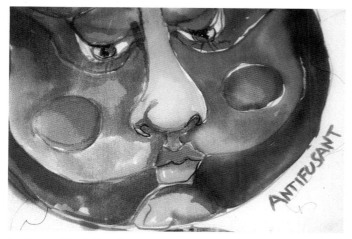

Jan Janas, *Mask* (detail).

USING ANTIFUSANT.

The entire surface of the silk is coated with an antifusant, which stops the flowing of the dyes. The effect is more layered and painterly.

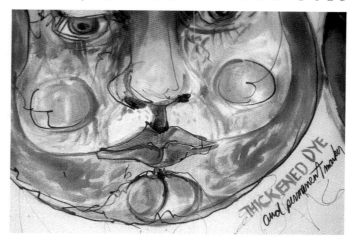

Jan Janas, *Mask* (detail).

USING DYE THICKENER.

Each color is thickened with dye thickener to completely control the flowability of the dyes. This technique is excellent for detail and layering of color.

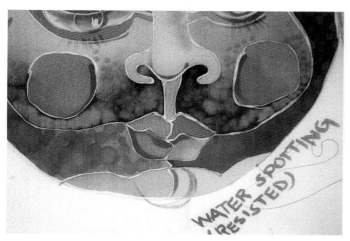

Jan Janas, *Mask* (detail).

WATER SPOTTING.

As long as the dyes are not steam-set, water and alcohol spotting will work. This is not possible with the instant set dyes.

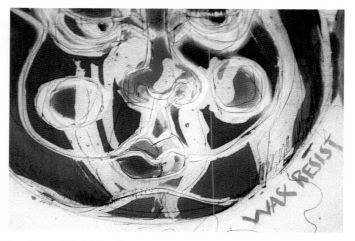

Jan Janas, *Mask* (detail).

WAX RESIST.

Melted wax is painted on with a brush for expressive lines of resist. Iron the wax out before steam-setting the flowable silk dyes.

WHAT A DIFFERENCE THE BRUSH MAKES

The brush you select plays an important role when using the instant set dyes because every mark is immediate and unmovable, and each brush makes a distinctive mark. The following exercise will give you an immediate feel for each stroke when it is applied to the silk.

STROKED EFFECTS

STEP 1. Stabilize a 10″ × 10″ piece of silk to freezer paper (see page 54).

STEP 2. Prepare three cups of diluted dyes of different colors and/or values.

STEP 3. Gather many different types of brushes (round, pointed, flat, fan, stencil, foam) and applicators (sponges,

feathers, cotton swabs, dye-filled markers, or anything else that looks interesting).

STEP 4. Stroke the brushes or dye applicator tools on the dry silk, working with diluted colors.

STEP 5. Vary the direction and the pressure of the strokes: Use the side and tip of the brush, light and heavy pressure, etc. You will quickly see the connection between the brush or applicator tools, the amount of liquid it holds, the pressure of the stroke, and the final effect. *All these factors are critical when working with a nonflowable dye.* This exercise will give you an intuitive "feel" for which applicator tool or brush to use to create a particular texture.

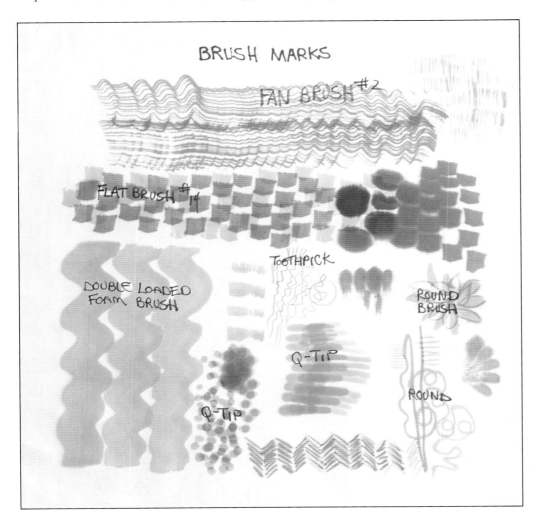

The brush you select plays an important role in silk painting. Each one makes a distinctive mark on the silk.

FLOW AND NO-FLOW

To develop the ability to control the instant set dyes, you need to grasp the significance of two important factors: stabilizing the silk and controlling the moisture.

Silk can be stabilized in one of three ways: by stretching it onto a frame, by ironing it to freezer paper, and by pressing it flat with water onto a smooth surface.

Knowing how much moisture to add to the brush and the silk to control the instant set dyes is critical. The level of the moisture in the silk (from prewetting) must be "just right," and the brush must be loaded with just the right amount of liquid color to make these dyes flow. If the silk is too dry, when you touch the silk with a properly loaded brush, all you get are textural strokes and instant bonding of the color to the fabric. If the silk is too wet, when you touch the silk with a properly loaded brush, the color will lie on top and will not grab the silk; the color hydroplanes.

To see if the brush is loaded properly, make a brushstroke on the silk. If all you get is a textural brushstroke, the brush is not wet enough. If all you get is a big puddle of color that bleeds outward, there's too much liquid in the brush, and you will lose control of the stroke.

MASTERING PAINT FLOW

STEP 1. Select a simple outline design. Use that design for all the samples.

STEP 2. Stabilize the silk using one of the three methods described on pages 54-55.

STEP 3. Prepare four cups: one with distilled water and three with different diluted colors.

STEP 4. Use the same brush for all samples.

STEP 5. First paint on the dry silk with a medium amount of dye.

STEP 6. Next dampen the stabilized silk by spraying it with distilled water. Paint with a medium amount of dye. This is the magic moment, when everything works together. You have achieved the best possible combination!

STEP 7. Prewet the stabilized silk with distilled water, and paint on the *wet* silk with a loaded brush. You will quickly notice that it is more difficult to move the dye because it hydroplanes on the surface of the wet silk.

Practice these important basic exercises. They'll give you a good grasp of the flow and no-flow aspect of the instant set dyes.

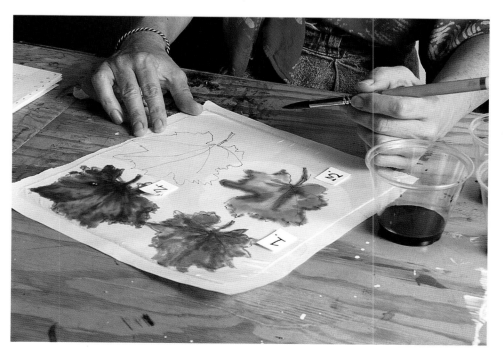

Different levels of moisture in the brush and on the silk are used to control instant set dyes.

FOLDING AND PAINTING

The art of folding and dyeing silk can be very simple or very sophisticated. The overall look is a kaleidoscope of color repeats and patterns. Like origami, the intricacies of the folds determine the beauty of the design.

Before you begin, practice folding and painting on paper towels. Your piece can be folded in squares, triangles, accordion pleats, combinations, etc. When you work on silk, always start folding with the silk dry. As the piece gets smaller, wet the silk for better control. Keep the folds as straight as possible so the repeats will be even. After each color application, check to see that the color has evenly penetrated to the other side.

STEP TWO.

PATTERNED EFFECT

STEP 1. Prepare several cups of diluted colors of different values.

STEP 2. Fold the dry silk following a pattern, such as a triangle, square, accordion pleat, or a combination of these. (See illustration.)

STEP 3. Wet the silk with distilled water so the layers adhere to each other. Squeeze out excess water between your fingers or palms until the silk lies flat. Blot between towels. Using a round brush, apply color along the folds. Do not overload your brush. Over this, paint a design of circles, stripes or zigzags. Check the back of the fabric. If the colors didn't penetrate all fabric layers, open the appropriate folds and add the missing colors. (See illustration.)

STEP 4. After the last color is applied, while the silk is still wet, open the folded silk. Notice that the dyes will not smudge even when wet. Rinse and iron. (See illustration.)

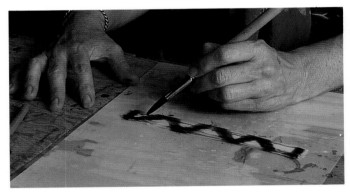

STEP THREE.

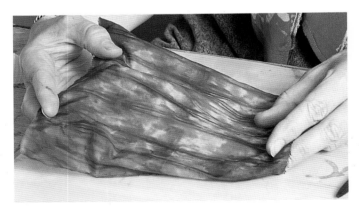

STEP FOUR.

DIP-DYEING IN A "SMALL WAY"

Dip-dyeing is probably one of the most versatile uses of instant set dyes. The first technique (below) creates evenly toned backgrounds or a base color to enhance some of the techniques described later in this section.

The second technique (sidebar, right) creates a faux marble or tie-dye look. It also produces a random two-tone effect.

BACKGROUNDS AND BASE COLOR

To dip-dye, fill one cup with distilled water and one with a light diluted color. Prewet the fabric in the distilled water; remove and squeeze out excess moisture. Dip the silk in a light color, and swish for a few seconds. Remove the silk, rinse in clear running water, and blot on a paper or cloth towel. Iron while still damp.

FAUX MARBLE OR TIE-DYE

STEP 1. Fill one cup with a light, diluted color and another with a dark color. Tightly crumple up your dry silk, and dip it in the light color. Squeeze out excess water. Uncrumple, then recrumple the silk. Quickly dip it into the dark color, remove, blot and iron while damp.

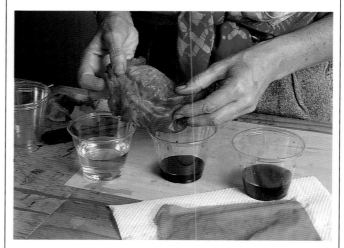

STEP 2. To increase contrast, repeat the process. The simplicity and versatility of dip-dyeing with instant set dyes is clearly illustrated. A flat, even background is easily exchanged for a mottled look.

TIE-DYEING

Remember how you loved to tie dye? This ancient method of dyeing requires minimum equipment and can be easily done by young and old. Traditional tie-dyeing with cold water and the instant set dyes is exceptionally easy on silk. Pressure barriers can be made by knotting, twisting, sewing, wrapping, tieing and folding the silk, using rubber bands or twine, threads, clamps or clothespins. Apply the colors with brushes, droppers and/or by dipping.

MARBLED EFFECT

STEP 1. Prewet the silk in distilled water. Take it out and remove the excess water.

STEP 2. Open the silk and place a few glass marbles or pebbles in the center.

STEP 3. Gather the silk around the shapes and secure with a rubber band at the top.

STEP 4. Tightly define the shapes by twisting a rubber band to enclose the marbles.

STEP 5. Dip into a cup of diluted dye.

STEP 6. Swish, check for color intensity and remove.

STEP 7. Remove the rubber bands. You can either rewrap and redip or leave as is.

STEP 8. Rinse and iron.

UNDULATING STRIPES AND ZIGZAGS

STEP 1. Prewet the silk in distilled water. Take the silk out, and remove the excess water.

STEP 2. Pleat the silk accordion style (horizontally, vertically or diagonally). To get zigzags after pleating, fold in half.

STEP 3. Bind the silk at intervals with twine or rubber bands.

STEP 4. Dip the silk in a diluted color.

STEP 5. Swish, check for color intensity and remove.

STEP 6. Remove binding. Either pleat again in a different direction and dip in a contrasting color, or leave as is.

STEP 7. Rinse and iron.

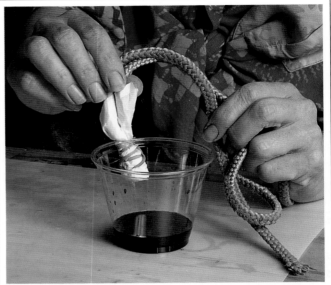

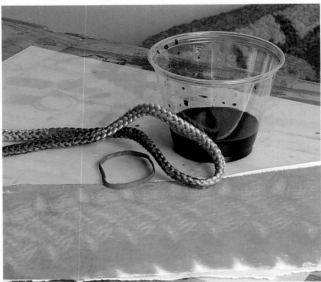

SNAKE SKIN

STEP 1. Roll the dry silk vertically, horizontally or diagonally around a heavily textured rope. Bunch it together tightly, fold in half and secure with rubber bands. Dip the silk in a cup of diluted color, swish and remove.

STEP 2. If desired, repeat the process by untying, retying and dipping in a contrasting color. Rinse and iron.

PATTERNING AND DIPPING

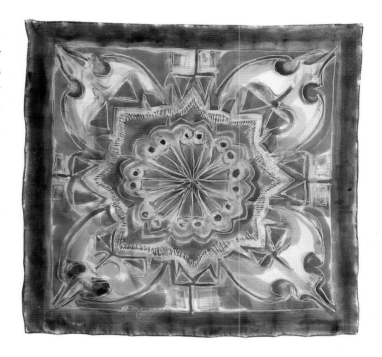

Using this technique you can dip-dye the entire piece of pre-painted fabric and add a pleasing background color to unify the design. This technique also combines well with other dyes and paints. After permanently setting the first product, follow the dip-dyeing instructions using instant set dyes. There's no need to set the fabric again. This technique is excellent when applied to yardage (see page 88).

BACKGROUND COLOR

STEP 1. Paint an initial design on the fabric using one or several techniques, such as stamping, resisting, stenciling with thickened dye or brushing.

STEP 2. Prepare two cups, one with distilled water and one with a diluted dye.

STEP 3. Dip the painted silk in the distilled water.

STEP 4. Remove and blot with paper towels.

STEP 5. Dip the silk in the diluted color, swish and remove.

STEP 6. Rinse and iron.

USING THICKENED DYE

To produce a crisp, painterly effect and to stop all dye movement in your silk painting, use thickened instant set dyes. The thickened dyes can also be used over other types of dyes for correction or enhancement, as a line of resist or for silk screening (see page 70).

STEP 1. Mix one part powder thickener and five parts distilled water with a hand mixer, or whisk until a gel forms. Allow this mixture to sit a few hours before using.

STEP 2. Gradually add drops of undiluted dye to the gel (which is thickened water) to reach the color intensity you want. Always add undiluted dyes to avoid washed-out colors.

STEP 3. The crispness of a thickened dye stroke is obvious against a stroke of unthickened dye. The colors remain transparent despite the thickener, and you can paint color over color. Use a hair dryer to shorten drying time. The gel stiffens the fabric, but that disappears with rinsing in cool water.

STAMPING WITH DYES

Stamping with thickened instant set dyes creates clean, crisp impressions. You can quickly overprint and dip-dye! The objects used to stamp with can be as simple as a sponge or as involved as a carved wooden block. Creative use of stamps can be very exciting. Here are some more ideas: Use multiple colors on a single stamp, or stamp one design over another. Look for unusually textured objects for stamping. Dip-dyeing or misting the silk before or after stamping adds a quick background color. To add bolder details to stamped designs, use permanent marking pens or dye-filled markers.

REPEAT DESIGNS

STEP 1. Prepare the thickened dye as described in the previous technique.

STEP 2. Stabilize the silk to freezer paper.

STEP 3. Choose your stamping object.

STEP 4. Spread a thin layer of thickened dye on a palette.

STEP 5. Press the "stamp" into the thickened dye to evenly coat with color.

STEP 6. Prestamp the object on a paper towel to remove excess dye.

STEP 7. Stamp the design on your silk.

STEP 8. Repeat steps 5-7 as many times as you wish.

STEP 9. Allow the silk to dry, then remove from the freezer paper.

STEP 10. Rinse and iron.

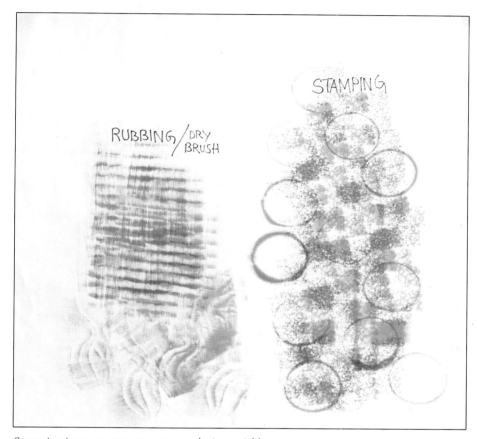

Stamping is an easy way to repeat a design quickly.

MISTING WITH STENCILS

Part of the excitement of spraying with the instant set dyes is that you can overspray while they're still wet on the silk. The dyes instantly bond to the silk with each layer of sprayed color. No need to worry about the dyes smudging. When the silk is stabilized with freezer paper, you have a flexible lightweight surface that can be moved and manipulated as you spray. Use stencils as a block out when misting. The shelf life of the prepared dye in the spray bottles is several months. Spray bottles can be refilled, and the dyes will go a very long way. Occasionally when spraying, larger spray drops will fall on the silk. Consider them as part and parcel of the technique. For your protection, use a dust mask when spraying.

Jan Janas, *First Snowfall* (detail), 8mm silk, 11" × 60" instant set dyes, line embellishment with fabric paints.

Part of the excitement of spraying with instant set dyes is that you can overpaint while the dyes are still wet.

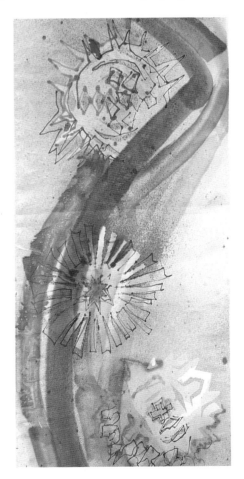

LAYERED COLOR

STEP 1. Fill a number of 2-ounce fine mist spray bottles with ½" to 1" of various dye colors. Then fill the bottles to the three-fourths mark with water/catalyst solution (see page 18). You can use an airbrush and paint jar attachment in place of a spray bottle.

STEP 2. Stabilize the silk to freezer paper or lay flat.

STEP 3. Position your purchased or handmade stencils on the silk in a pleasing arrangement. To cut your own stencils, use Mylar, stencil paper or freezer paper. Experiment with positive- or negative-shape stencils.

STEP 4. Begin with the lightest color, and hold the spray bottle 6" from the silk. Spray forcefully with a continuous pumping action.

STEP 5. Blot the stencils with paper towels before removing the stencils.

STEP 6. Reposition the stencils on the silk, and spray with a middle-value color.

STEP 7. Repeat steps 5 and 6 for a layered effect.

STEP 8. Spray the darkest color last.

STEP 9. Remove the silk from the freezer paper.

STEP 10. Rinse and iron.

STRIPED PATTERNING

STEP 1. Experiment with stripes and plaids using this technique. After stabilizing the silk with freezer paper, pleat the silk accordion style with very sharp creases. Drop this three-dimensional accordion on the work surface with the pleats open, silk side up.

STEP 2. Using your lightest color, spray the tops of the pleats at an angle on one side only.

STEP 3. Using your middle value, spray the tops of the pleats from the opposite direction.

STEP 4. Completely open and flatten out the pleats. Observe the striped patterning!

STEP 5. Pleat the stabilized silk again in a different direction.

STEP 6. Respray each pleat top with the color of your choice. This repeated spraying creates intricate plaids. Stamping or brush stroking can also be used to enhance the pattern.

WAX PAPER RESIST

We stumbled on this technique when a student accidentally used wax paper instead of freezer paper to stabilize the silk! The transferred wax resisted the dyes. We were immediately intrigued with the possibilities. Can you imagine a batik effect without hot wax? Well it works. As the wax paper is ironed to the silk, a thin temporary coating of wax covers the surface. This wax coating gradually dissolves as the silk is dipped or painted in successive layers of color. The wax painted images become fainter and fainter with each successive layer. The wax paper shapes can be ironed on smoothly for an even look or crumpled for an interesting organic texture.

BATIK EFFECT

STEP 1. Cut, rip or crumple shapes from wax paper.

STEP 2. Lay the shapes on one piece of silk, and place a cloth or paper over them to protect your iron. Iron on the "silk" setting. (See illustration.)

STEP 3. Remove the wax paper shapes.

STEP 4. Prepare three dyebaths: one light, one medium and one dark color.

STEP 5. Dip the silk in the lightest color. Let dry.

STEP 6. Repeat steps 1-3.

STEP 7. Dip silk in the medium color. Let dry.

STEP 8. Repeat steps 1-3.

STEP 9. Paint or dip silk in the dark color. Let dry. (See illustration.)

STEP 10. Rinse and iron. No need to go through the tedious process of ironing out the liquid wax!

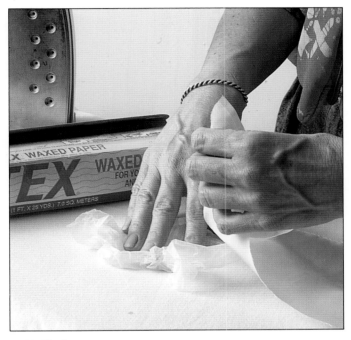

STEP TWO.

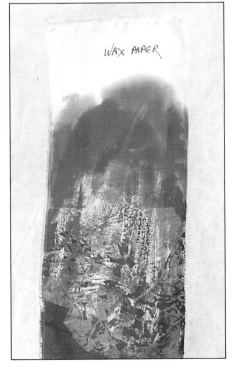

STEP NINE.

PART TWO

Creating Creatively

CREATING BY DESIGN

As an artist first viewing silk paintings, you are probably immediately taken with the fluid, expressive possibilities. The natural sheen of silk in combination with dyes creates a "magic" that makes silk painting a unique art form. Your first reaction is, *How can I express my own vision in this incredible medium?* Once that thought enters your mind, you are intrigued and you want to do it!

Like the writer who is faced with a white page and the deep desire to write, you are confronted with *white silk!* What to do and where to start? Where do I get my inspiration?

To express your silk painting ideas, you must learn to select, control and master the medium and materials. You need to become familiar with all the intimate aspects of the medium. To begin, invest in a few products and books. Sign up with qualified teachers whose workshops will teach you the basics. As you progress, continuing education becomes critical. Exploring ideas with good, open-minded teachers and inquisitive fellow students in a creative atmosphere is intellectually stimulating. You will often have to meet the challenge of working better and harder at the workshops, which will translate into inspiration, focus and growth.

Take the time to consciously access your creative path. The process includes research, sketching preliminary ideas, meditation and visualization. You will find it helpful to write de-

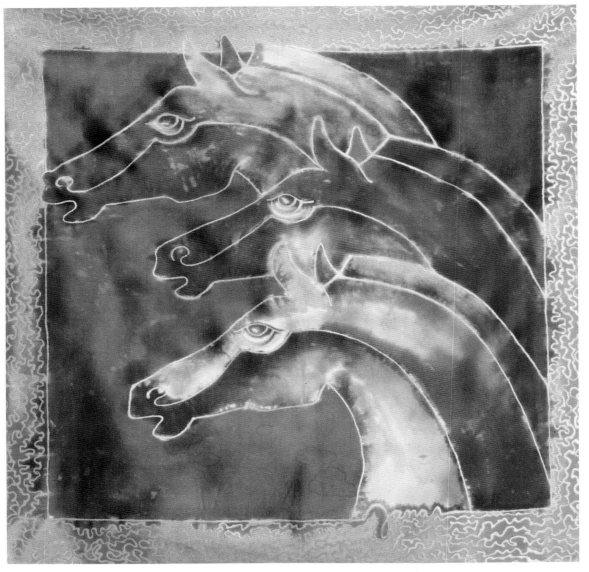

Jan Janas, *The Race* 15" × 15"

THINK IN PAIRS. This flat crepe preconstructed pillow cover was painted with instant set dyes embellished with metallic fabric paints.

scriptions and list the components of your projects, along with making thumbnails of these ideas. As your ideas gel and are narrowed down to essentials, you will experience confidence. When the elusiveness of the process has disappeared, all you will feel is elation!

Even a single image or a line can become a trail to your creative path. Visualize your ideas in a location where the atmosphere is conducive to this activity. Soften the lighting, play music, and close your eyes halfway to establish a mood. You will gradually develop a plan, but the name of the game is flexibility.

All your memories and experiences become part of the unconscious creative process. As you absorb and distill visual information, over a period of time you will create your own unique vision. To keep your perception fresh, cultivate a childlike approach to your artwork. Break away from your sense of security as you explore unchartered artistic areas. As an example, color is completely open-ended, yet most artists get caught in a rut and repetitiously use the same colors and designs in their work. Let intuition rule reason for originality in your art. Following are some idea-sparkers to get you started.

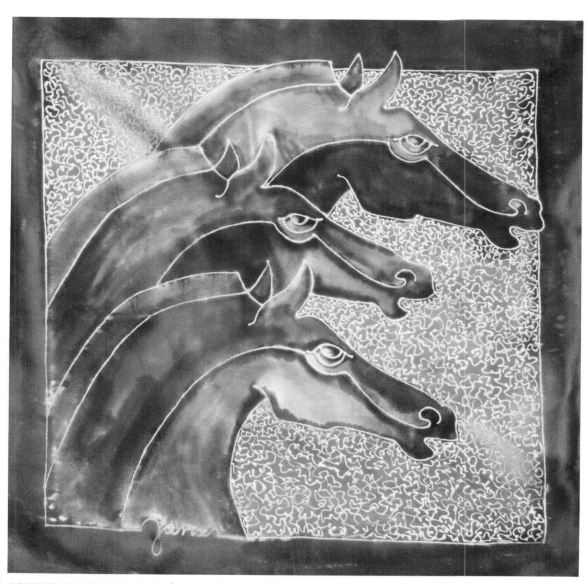

REVERSE A PATTERN. A simple reversal of the pattern and color placement, Janas effectively created two very different, yet complementary, pillow tops.

CREATING WITH REPEATED SHAPES

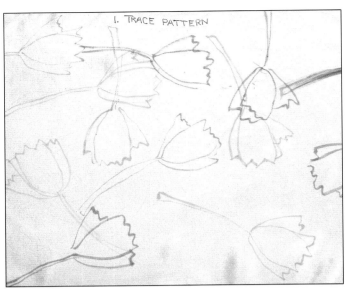

STEP 1. Trace a single flower shape onto the silk with a brush in a random (or sequential) pattern.

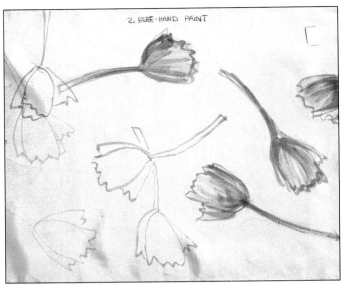

STEP 2. Quickly paint the flower shapes with different colors of varying intensities.

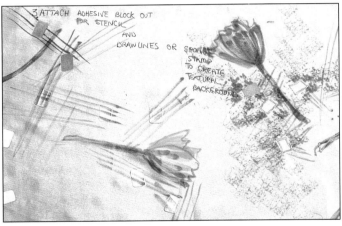

STEP 3. Attach adhesive labels to act as blockouts, and paint lines and textural sponge stampings over these blockouts.

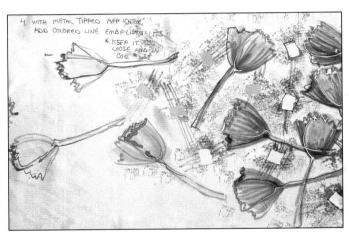

STEP 4. Apply orange opaque paint around the flowers as a decorative outline. Remove the adhesive label blockouts to expose a smaller, contrasting shape. As you can see from this exercise, it only takes one shape to get a design going. The flower shape can be repeated either randomly or systematically. The addition of the geometric adhesive-backed square blockout resists adds a whimsical detail.

M. Newman,
Monteverde, fiber-
reactive dyes, silk
noil.

USING REPETITIVE PATTERNS. Can you see the garment? Using
a monochromatic color scheme of greens and black, Newman used
wax resist, block printing and immersion dyeing to capture the
essence of repetitive leaf patterns.

CREATING WITH QUILTING EFFECTS

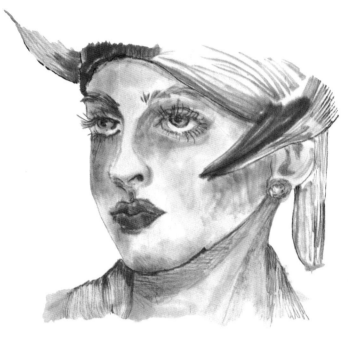

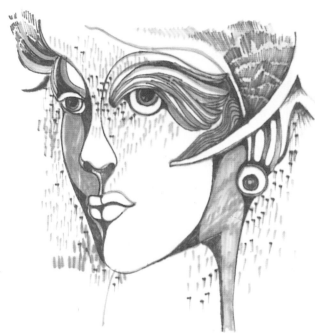

STEP 1. To become better acquainted with the quilting process, Janas took a class in color and design for quilters. The lesson plan called for the selection of a design that would be used throughout the ten-week course. Jan began by realistically interpreting a face, placing special emphasis on the lips and the hat.

STEP 2. She then simplified and abstracted the face.

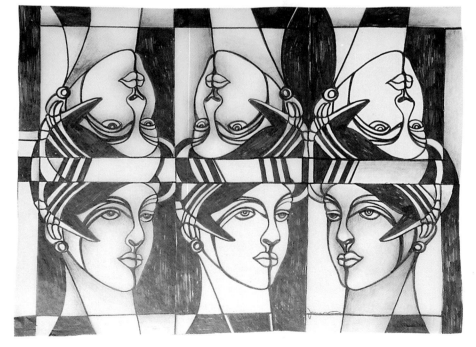

STEP 3. Using values (black, white, gray) Janas drew a single face repeatedly with quiltlike borders on paper. Each face represented a quilting square. While this would be a successful design for a quilt, Janas decided that yardage for artistic attire was to be her new goal.

Jan Janas, *Face—Colette*, 8mm china silk, instant set dyes.

STEP 4. Jan finalized the basic design, and drew a prototype to be used for the repeating design.

STEP 5. She photocopied the face in various sizes, manipulating the shapes in a pleasing arrangement. The half drop-repeat design, left, was the most exciting. She selected silk shantung for the slacks and lining. Silk broadcloth was selected for the sleeveless jacket. The entire outfit was to be painted with instant set dyes.

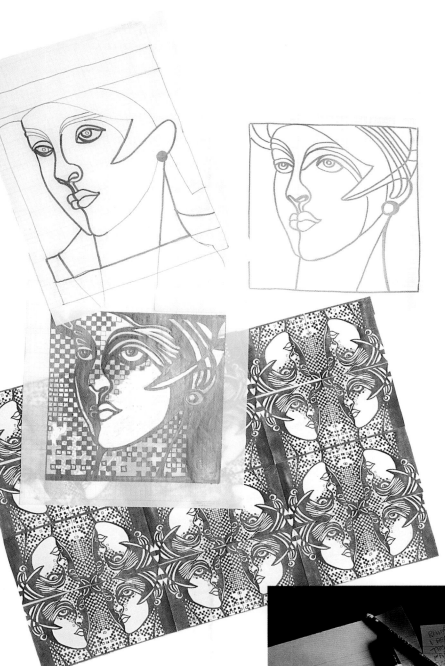

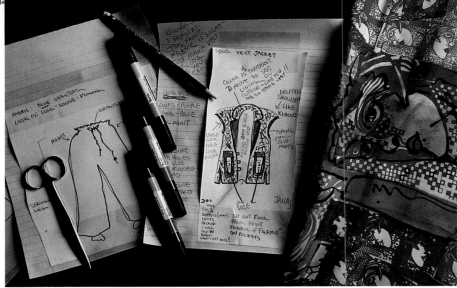

STEP 6. The fabric was silkscreened (see page 70) and hand-painted, then sent with thumbnail sketches and detailed notes to the seamstress.

REINTERPRET A GOOD IDEA

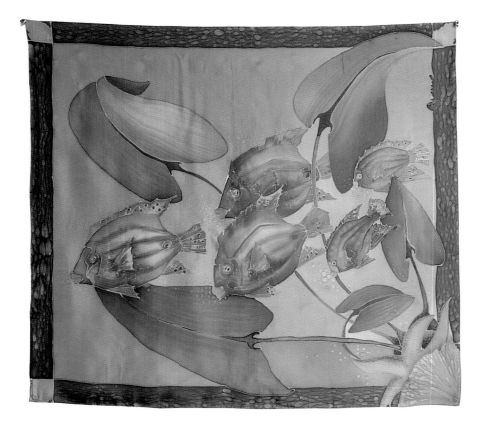

Jan Janas, *Fish School I,* 8mm china silk, 30″ × 30″, steam-set dyes.

This design started out as a one-day class project to teach beginners water spotting, resisting and ombre effects. This piece is toned color, static and decorative. Note the effective spillover of the design into the border.

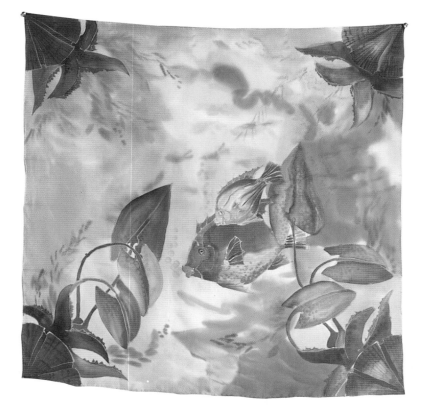

Jan Janas, *Fish School II,* 8mm china silk, 30″ × 30″, steam-set dyes.

A reinterpretation of the *Fish School I* design. The whole mood of this design is changed by new placement of the same shapes, a brighter color scheme and new techniques. This work has a fresh look with depth and movement. Note the dynamic wet-on-wet background.

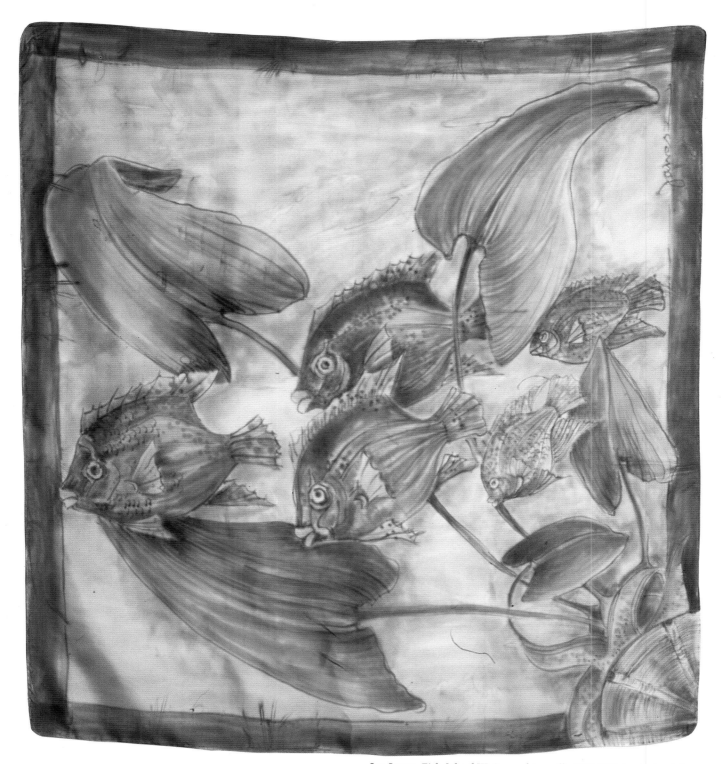

Jan Janas, *Fish School III*, 8mm china silk, 30″ × 30″, instant set dyes.

This is another reinterpretation of the *Fish School I* design. This work was painted flat on a table, unstretched, with no resist used. The subtle, soft definition between shapes gives this interpretation a fluid look. Note: The smoother transition of the fish hiding among the leaves gives the illusion of underwater depth.

This outfit is the result of a long and fascinating process. It took Janas five different approaches on how to use the face design before she decided which direction she wanted to go with it. "Once I focused on my vision, creative activity flowed and it all fell into place. My biggest thrill was to see the result when I opened the box the seamstress returned!"

CREATING WITH COLOR

When working with color, silk painters, even experienced ones, tie their hands behind their backs. We constantly hear comments like: "It's too hard to remember all the rules!" "I can't figure out exactly how the color wheel works." "What color goes with this one?" "Does this color work with the others?" Stop fighting learning about color. *Liberate yourself!* Untie the ropes that bind you, and explore this fascinating subject.

To understand color, you must use it, and you must train your eyes to *see* it. It takes more than reading books and learning the rules to know about color; it takes experience. The more you work with color, the more you will become intuitively aware and open to the colors around you and how they fit together.

So how do you bring this excitement about color to silk painting? We think the best way is experimenting through painting exercises. So follow the (colored) silk thread, and experience this adventure.

The addition of color transforms a strong design into a patchwork of color.

COLOR CHART

Get acquainted with your dyes. Stretch enough silk to paint a color chart with the silk dyes you already own. Working on your stretched silk, resist as many areas as you have colors, in any shape you wish. To keep the colors pure, paint in each color with a clean cotton swab. Jot down all your observations about each color directly on the silk with a black marking pen. For example, "bleeds slow," "love this color!" etc.

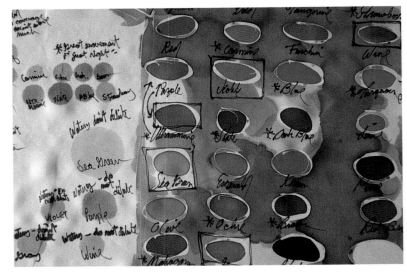

A color chart.

COLOR SWATCHES

Color swatches are quick, inspirational tools for creating unusual color schemes. Making these swatches may seem like a long and arduous task, but after you're finished, you will have a thorough understanding of color mixing.

Begin by cutting out 5"×5" squares of silk (10 momme), one for every color you own, and paint each square with one of those colors. These are your first swatches. Cut a 4"×4" cardboard square for each silk piece. Tape each painted silk square to a cardboard square, tucking the edges around the back. Label the back of the swatch with the name of the color, date and product. Now, stretch and resist five more 5"×5" squares of silk for *each* color.

Now let's be creative with the colors you own. Mix colors without any prejudice or preconceived ideas. Make new hues, some light, dark or toned. How many browns and blacks can you mix? Experiment. Paint the extra silk squares with a selection of your mixtures, mount them on the cardboards, and record the formulas on the back.

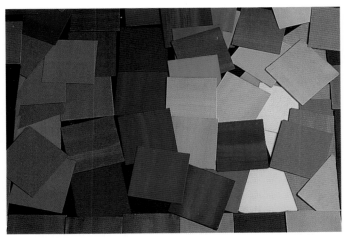

Color swatches.

EXERCISE

COLOR WHEEL

Now you will use your dyes to make your own original color wheel in any size, shape or design you like. Using only your three primaries—yellow, red and blue—you will create all the other colors on the wheel. First, mix each of your three primaries to get three secondaries: orange, green and violet. Now mix each primary with a secondary to get six tertiaries: yellow-orange, red-orange, yellow-green, blue-green, red-violet and blue-violet.

Color wheel.

MONOCHROMATIC COLOR

Select any color from your mounted color swatches and a black. Mix them together in various combinations to create and paint a simple design.

Monochromatic color scheme.

ANALOGOUS COLOR

Choose colors that share a common primary, such as yellow: yellow-greens, yellow-oranges, blacks. Mix them together in various combinations, and paint a simple design.

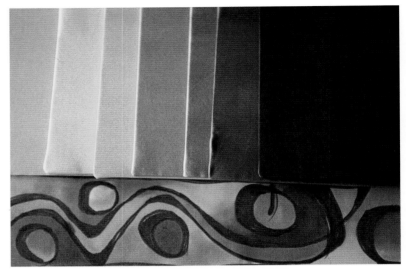

Analogous color scheme.

COMPLEMENTARY COLOR

Select one primary and a mixture of the two remaining primaries, such as blue and orange plus black. Mix in various combinations, and design a painting with them.

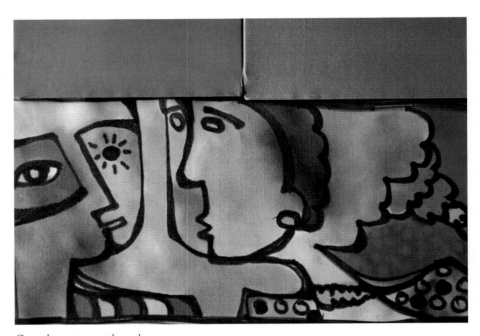

Complementary color scheme.

USING THE COLOR SWATCHES

Color swatches can help you determine the amount of a specific color to use within a color scheme.

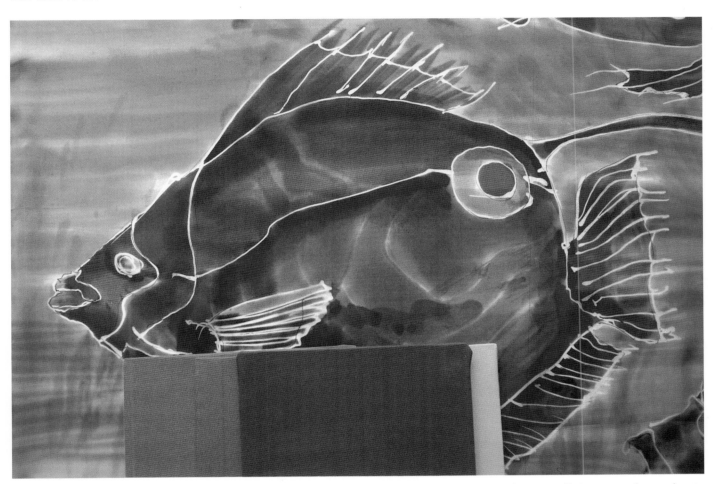

Jan Janas, *Tropical Fish* (detail), 10mm silk, instant set dyes and gutta resist.

Use color swatches to determine color proportion.

TWO-COLOR EXPERIMENT

Try mixing just two colors in various quantities and values to see what an amazing visual impact you can get. Try any combination of colors and strip widths.

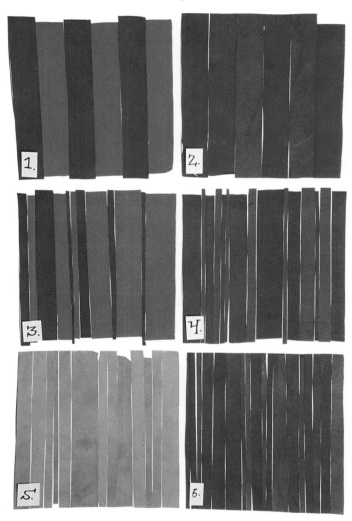

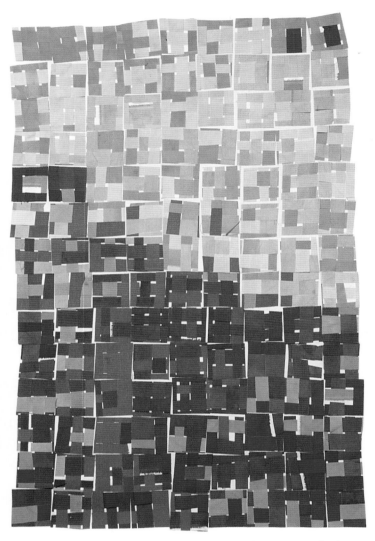

Here you can see how to create a range of effects using just two colors: (1) equal size strips of two pure colors; (2) equal size strips, one color is pure, the other is a mixture of two pure colors; (3) unequal size strips of pure colors; (4) repeat of #2 with unequal size strips; (5) unequal size strips of diluted pure and mixed colors; and (6) unequal size strips with pure and mixed colors intermixed in varied proportions.

Jan Janas, *Value Judgment*, 10mm silk, 18"×24", instant set dyes.

This working model for a quilt design uses the leftover strips of painted silk from the two-color exercise. The strips were cut in different sizes and arranged according to value and contrast.

VALUE CHART

This exercise will give you a working understanding of how to obtain a variety of grays from black (see Immersion Dyeing section page 58). Rip ½ yard of silk into thirty 2″ × 4″ strips. Soak all the strips in the soaking solution. Lay out five clear plastic cups. In the first cup, add about an inch of black dye. In the rest of the cups, add progressively greater amounts of water. With a dropper, add black dye from the first cup to the other four cups of water. Experiment with the quantity of water and dye until the cups are graded in roughly equal increments.

Take out one soaked strip, blot out excess moisture, and plunge into black dye. Remove and place on a paper towel. Let dry. Repeat the dipping process in the other four cups of diluted dye of different values. You will need to do almost thirty strips to get an accurate visual gradation from black to white (you will discard the ones that don't work). To accomplish that, you will need to keep adding dye or water to the cups to obtain different values. Paint a long strip of middle-value gray, and place it to the left of the value scale. Notice that this strip of middle gray appears lighter or darker depending on the value it is placed near.

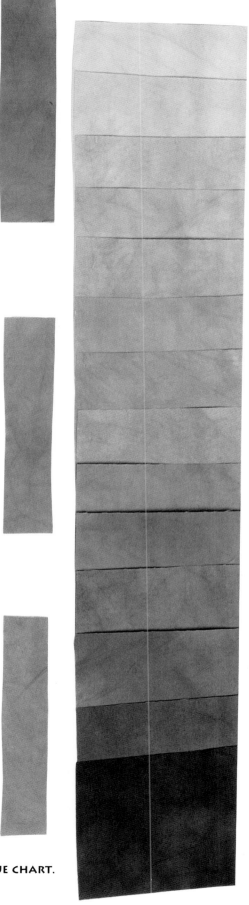

VALUE CHART.

SATURATION (INTENSITY) AND VALUE CHART

Using the same method as the preceding exercise, we now mix a color with black. We chose yellow, but you can mix any color you wish with black.

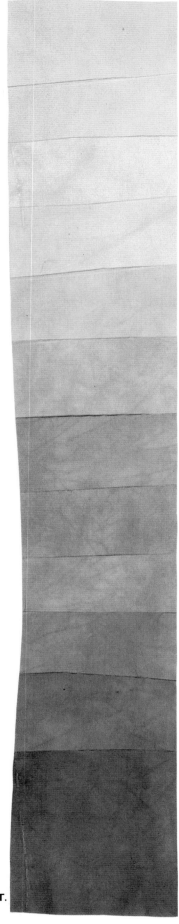

SATURATION AND VALUE CHART.

COMPLEMENTARY COLOR CHART

Experiment in color temperature (warm and cool) and intensity (brightness and dullness). Make a chart like that in the previous exercise, using two complementary colors. We chose green and red, but you can choose any complementary colors you want (e.g., orange and blue, yellow and purple). Since these are complementary colors of approximately the same middle value, as you mix them, the value stays constant but the intensity and color temperature (warmth and coolness) change as you add more and more of the complement. In this case, green is being added to the red in small increments, so the red is getting more and more neutral—and darker (because they're dyes, not paints).

COMPLEMENTARY COLOR CHART.

TO STRETCH OR NOT TO STRETCH

In the past, a technical approach to silk painting was emphasized and one almost always stretched silk on a frame. To be a flexible, creative silk painter, you should know how to stretch silk. Stretching creates a smooth, taut surface for the resist to be applied in a thin line that easily penetrates the silk and creates an effective barrier. The dyes can then flow unimpeded through the taut silk within the outlined shapes. Stretched silk eliminates any chance of the dyes coming into contact with the worktable, which would smudge the resist and the colors. At present, however, since it is no longer essential to have crisp resist lines and smooth painted areas, silk painting artists view stretching as only an option.

The objective is to stretch the silk tautly on a frame using pushpins. The silk is suspended and does not touch the frame or the work surface. Depending on the size of the project, you will use either canvas stretcher strips, homemade frames, lengths of lumber attached with C-clamps, or one of the many silk painting frames now available.

When selecting the size of your frame, the inner dimension (open section) is the actual size of your painted piece. Thus a 30"-square scarf is stretched on four 32" canvas stretcher strips.

For innovative alternatives to traditional stretching, try these different approaches.

Jan Janas stretched this piece of silk loosely over a box, hanging it like a hammock. She draped the fringe over the edge of the box, then dyed the fringe as it hung from the box by dipping it, a section at a time, into blue dye mixed in a plastic cup. Each time she dipped, Janas squeezed and blotted the excess moisture from the fringe before moving on to the next section.

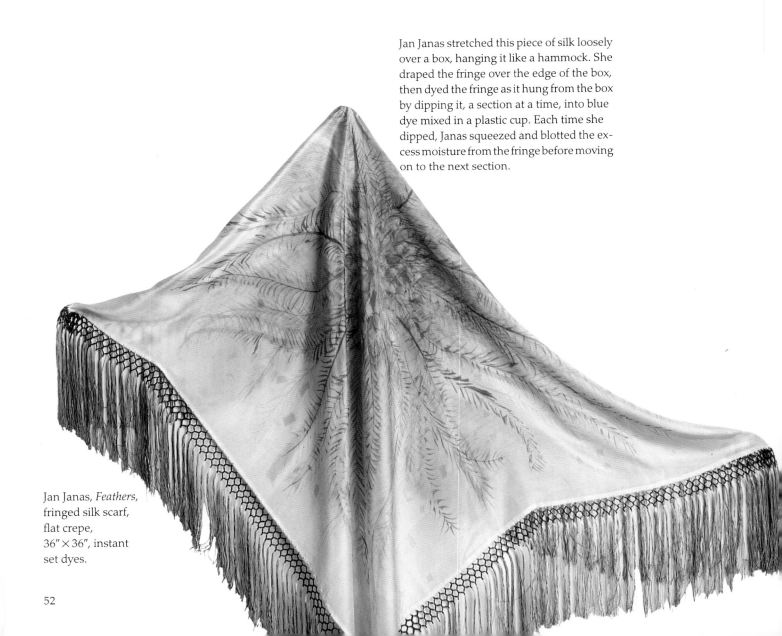

Jan Janas, *Feathers*, fringed silk scarf, flat crepe, 36" × 36", instant set dyes.

STRETCH SILK WITH TAPE

One of our students cleverly figured out a fast and easy way to stretch silk using tape. First cover the stretcher strips with wide, clear, good quality packing tape to protect the wood from dye stains and to prepare the surface for the next step. Cut another piece of tape to fit on the front surface of the frame and long enough to reach the frame's outer edges. Press down only a third of this tape, and roll it back onto itself to form a self-sticking surface. Repeat this procedure on the other three sides of the frame, and press down firmly. You are now ready to stretch the silk. Press the silk down smoothly, tautly and straight onto one edge of the taped frame. While holding down one taped corner of the silk, pull the second side tautly and press down. Repeat this procedure on the third and fourth sides. If the silk is not smooth and taut, lift, pull and press down again. Before painting, draw a line of resist around the inner edge of the silk to avoid getting the tape wet. (Wet tape will not hold the silk.) Remove the silk from the tape as soon as you have finished painting.

After covering the stretcher strips with clear packing tape, line the inside opening of the frame with more tape that has been rolled to form a self-sticking surface.

STABILIZE WITH FREEZER PAPER

The T-shirt painting technique that used freezer paper as a fabric stabilizer inspired us to try it with instant set dyes. It's simple! Iron the silk to remove wrinkles. Then take *plastic-coated* freezer paper, available at food stores, and cut off a piece a little larger than the silk. Place the shiny side of the paper on the silk. Set the iron on the "silk/wool" setting. Iron the dull side of the paper until the fabric adheres. The silk is now stabilized and ready to paint, mist, silkscreen or stamp. After you have finished painting, gently peel off the freezer paper from the back of the silk. *Caution*: Do not iron wet or damp silk to the freezer paper. It will be very difficult to remove the paper from the silk unless you reiron it.

LOOSE STRETCH

"Loose stretch" is the only way to describe this discovery. We were trying to show off the ease and versatility of the instant set dyes at a convention. Someone brought us a fringed scarf and challenged us to paint it on the spot. We looked around and found an empty box and four pushpins. The scarf was slung over the box and secured at the four corners with pushpins. This "silk hammock" was very conducive to some creative painting techniques.

Secure the fringed scarf over a box with a pushpin in each of the four corners.

STABILIZE ON ADHESIVE BOARDS

While waiting to select a mat for a silk painting at a frame shop, we noticed acid-free pH-neutral adhesive boards. We were intrigued with the possibilities and found that the silk adheres easily to the board. When you're done, just slip the completed work into a frame. (You can also paint your silk, then attach it to this board before framing.) These boards work particularly well with instant set dyes and liquid silk paints. The simplicity of this method is an incredible advantage for silk painters. What a find for artists who sell their work in galleries, too!

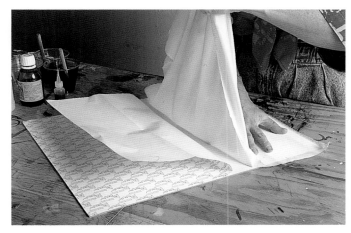

Stabilize fabric on adhesive board.

STABILIZE ON A SMOOTH, FLAT SURFACE

Again the instant set dyes created the impetus for this shortcut. Use a smooth piece of clean glass, Plexiglas, or old countertop (that you don't mind staining). Place the silk on the flat surface and spray with water. Using a brayer, foam brushes or your fingers, smooth out the silk until it adheres to the work surface. You are now ready to paint, spray and/or stamp the silk. This method of stabilizing the silk is quick and works well with other dyes, too.

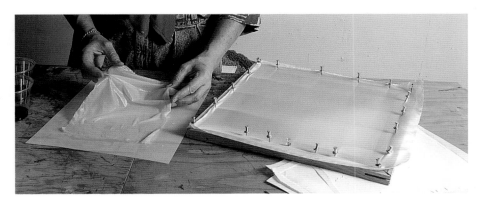

Stabilize fabric on a smooth, flat surface.

ADVANCED TECHNIQUES

We believe that if you want to create in a new way and flow with the dyes, you can't be bogged down in lengthy, involved techniques that force you to lose your creativity somewhere in the complicated processes. You've got to know and understand these traditional techniques, but you've got to pick out their essences and adapt them to more streamlined, modern ways.

In this section, we look at five complex traditional techniques. Although we regard these traditional techniques with reverence and respect, we needed to adapt them to our painting style and personalities. We just couldn't sustain the creative excitement over such lengthy processes unless we could simplify them to their essentials. We offer, in this section, the shortcuts we've discovered as a result of our experimentation with these techniques. This is only the tip of the iceberg. We hope to inspire you to come up with shortcuts of your own.

In the first technique, immersion dyeing, we offer a quick way to color yardage. In the second technique, our interpretation of batik, we show how to use wax—the perfect resist—without immersing the fabric between wax applications. The next three approaches deal with shortcuts in duplicating your designs for multiple repeats: block printing, katazome and silkscreening. Each one has its own distinctive look and can reproduce exquisite details. Repeating these detailed designs would otherwise be time-consuming, uninteresting, and difficult to hand-paint. The flexibility of these three techniques permits you to vary each print, by your choice of colors, placement and product.

The illustrations in this chapter show how to do these techniques. This is to inspire you to *try me*. For in-depth information on any specific technique, we highly recommend hands-on classes.

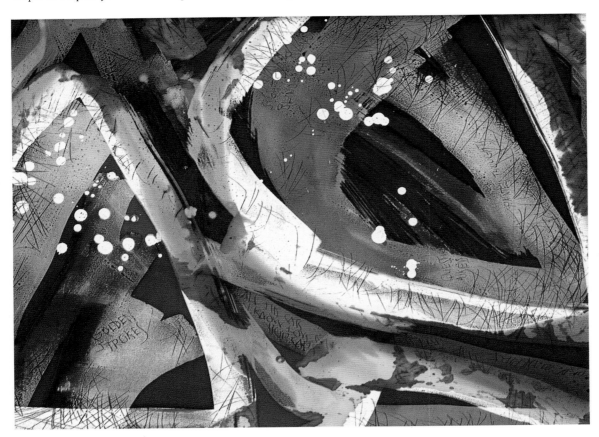

Jan Janas, *Golden Strokes*, heavy charmeuse, 24" × 36".

Jan Janas, *Tulips* (detail), yardage, 12mm crêpe de chine, instant set dyes embellished with gold fabric paint.

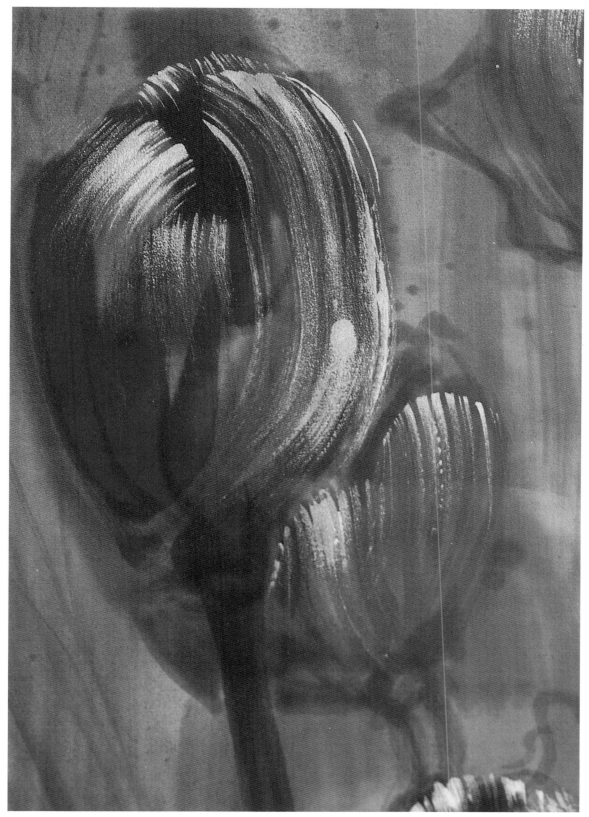

After the motif was loosely painted, the fabric was immersion dyed in a bath of pale fuchsia.

IMMERSION DYEING

Instant set silk dyes have opened up a whole new world in immersion dyeing. This exciting development allows the fiber artist and the silk painter to quickly dye protein fibers, yarns, and fabric by the yard. It's a simple process requiring cold water, salt, vinegar, and just a few minutes. It can be done in a bowl, a bucket, or even a washing machine. It's practically fail proof because of the simplicity and predictability. Before beginning the hand- or machine-wash process, be sure to read the tips (below, right), and learn how to avoid some common problems.

Creative Applications

With instant set dyes, you now have the ability to incorporate immersion dyeing in your projects at any point in the creative process. Dyeing the whole piece of silk lets you instantly unify the color scheme and harmonize the colors on the fabric. Here is how.

- When you're pressed for time, immersion dyeing can be a lifesaver when you encounter problems of harmony. Quickly solve these problems, at the last minute, in a simple dyebath.
- Overdyeing with instant set dyes is also effective in conjunction with other types of dyes.
- Fabric linings can be easily dyed to match your one-of-a-kind painted or handwoven garments.
- Quickly and dramatically you can change the color of an entire ensemble by immersion dyeing.
- Large-scale wall hangings, screens or framed paintings often require a quiet, yet powerful, background to contrast with intricate compositions. You can get this effect—continuous flat backgrounds—with selective immersion dyeing. The background can be dyed first, before the painting begins, or last, to quickly and easily unify the color scheme.

For the creative silk painter, when it comes to immersion dyeing, our motto is: Don't hesitate, just do it!

IMMERSION BY MACHINE

STEP 1. Set washing machine on the gentle cycle and *cold* water. Fill the machine and add 3 cups of white vinegar, 3½ cups of salt, and 1 tablespoon of catalyst. Agitate this mixture for three minutes, and return the cycle to "start."

STEP 2. Add the silk and agitate five minutes longer. Remove the silk and return to "start."

STEP 3. Remove a quart of the soaking solution from the washing machine. Add the selected undiluted instant set dye or dyes to this liquid and stir well. Return it to the washing machine, and agitate for thirty seconds.

STEP 4. Test the color in the dyebath with a small silk swatch. Dry the swatch to check for color intensity. If it's too light, add more dye. If it's too dark, add more water.

STEP 5. While the machine is agitating, gradually add the wet silk and run it through the full program for five minutes.

STEP 6. Run the washing machine again through the *cold* water, rinse cycle only. You can add a few drops of silk shampoo and ½ cup vinegar at this time.

TIPS FOR IMMERSION DYEING

- Use *cold* water.
- For stirring, use plastic utensils because metal reacts with the dyes.
- Possible reasons for uneven dyeing:
 1. The silk was not completely submerged and evenly wet in the soaking bath.
 2. The fabric was not submerged swiftly enough into the dyebath or stirred adequately.
 3. The fabric was pre-treated with a repellent finish.
 4. The fabric was not silk!
- Save all your immersion dyebaths in glass or plastic covered containers for reuse. They will keep for days or even weeks. The colors gradually get paler as the dye is spent.

STEP 2.

STEP 4.

STEP 5.

STEP 7.

IMMERSION BY HAND

STEP 1. Fill a container half full with cold water (tap or distilled). Prepare a soaking solution by adding ½ teaspoon of catalyst, ⅛ cup white vinegar and ¼ cup common table salt per gallon of cold water. Stir thoroughly with a plastic utensil.

STEP 2. Soak the silk in this solution approximately seven minutes per yard, swishing periodically. The silk *must* be completely submerged and evenly wet. Remove the silk, squeeze out the excess moisture and set aside. (See illustration.)

STEP 3. Add the selected undiluted dye(s) to the soaking solution. Stir thoroughly. Test the color in this dyebath with a small silk swatch. Dry the swatch to check for color intensity. If it's too light, add more dye and soak longer. If it's too dark, add more water.

STEP 4. Loosen the wet silk, and plunge it all at once in the dyebath. Swish the silk continuously, allowing the dye to reach all areas evenly. Wear rubber gloves to avoid dye-stained hands. (See illustration.)

STEP 5. When you are satisfied with the color, remove the silk from the dyebath, and gently squeeze out the excess dye. Place the silk in the sink, and rinse it under cold running water until the water runs clear. (See illustration.)

STEP 6. Add a few drops of silk shampoo and a tablespoon of white vinegar per gallon of water to the final rinse. Rinse again and remove the silk.

STEP 7. Squeeze excess water from the silk, and roll up in sheeting, muslin or toweling. (See illustration.) Unroll and iron the silk while still damp.

BATIK

Batik is a dyeing process in which a melted wax resist is applied to preselected areas, and the fabric is then dip-dyed. When dry, wax resist is added to another area, and the fabric is dip-dyed again. This sequence is repeated as desired. While the traditional approach is to dip-dye the fabric, you can also apply the dyes with brushes.

Batik can be involved, time-consuming and messy, yet it is well worth the effort because we consider wax to be the "perfect" resist. The fluidity of the hot wax gives you an extremely expressive, yet crisp, line. The application is immediate and you can paint over it with abandon!

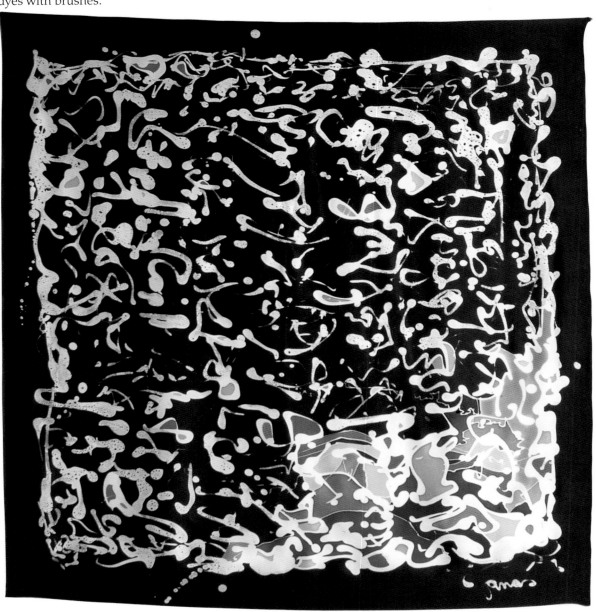

Jan Janas, *Midnight Jazz*, silk Charmeuse scarf, 36″ × 36″, French steam-set dyes.

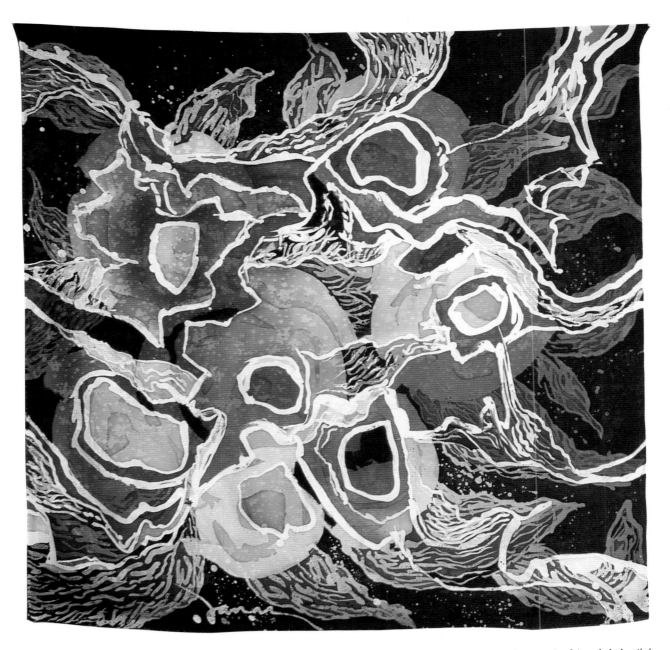

Jan Janas, *Floral Abstract*, silk Jacquard scarf, 36" × 36", French steam-set dyes.

Janas creates interest in this subtle batik by the extensive use of the white wax resist line to create movement. Crackling was not included in this batik because it would have detracted from the linework.

(left) An expressive continuous line was applied with a tjanting tool while listening to jazz at night. The black dye was painted in flat applications, with areas of bright colors for interest.

THE BATIK PROCESS

STEP 1. Working in a well-ventilated area, heat one part beeswax and two parts paraffin wax in an electric frying pan set at 160 to 170 degrees. Don't overheat the wax; it can catch on fire. And avoid breathing wax fumes. Once the wax is melted, maintain the temperature at around 130 degrees. Stabilize the silk by stretching it on a frame.

STEP 2. For a broad line, apply the hot wax with a foam brush. Bind the head of the foam brush to its wooden handle with a string to prevent the heat of the wax from separating the foam from the handle.

STEP 3. Use an old, stiff paint brush for a thinner line. Because a small brush holds only a limited amount of wax, the application is uneven and interesting in contrast to the broader line of the foam brush.

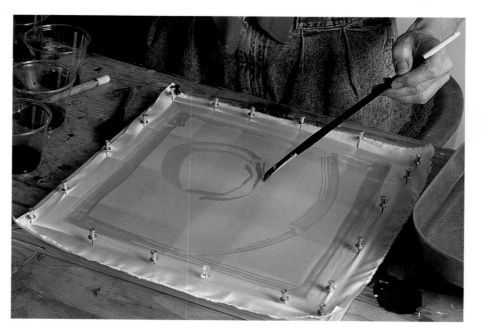

STEP 4. Brush on the lightest color first, working directly onto the stretched, resisted silk. When the dye dries, draw a squiggly wax resist line using the tjanting tool.

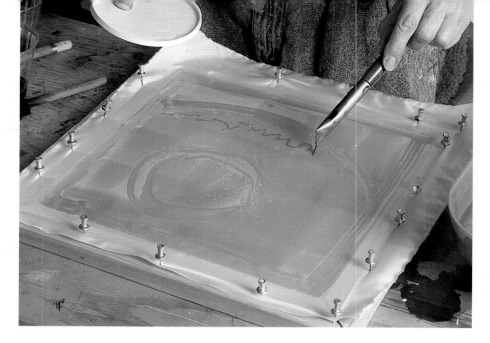

STEP 5. Paint on the next lightest color with a foam brush over the entire surface. It dyes only in areas that are not resisted by wax.

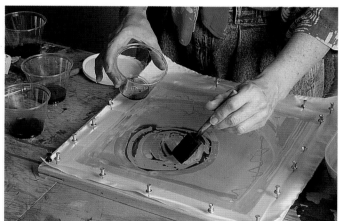

STEP 6. Repeat the process with wax and dye applications.

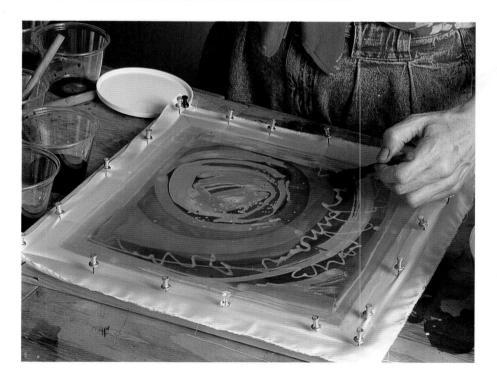

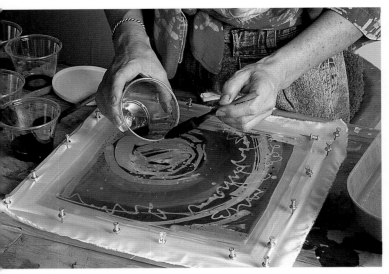

STEP 7. Brush on the most intense color before you apply the final and darkest color. Allow dyes to dry.

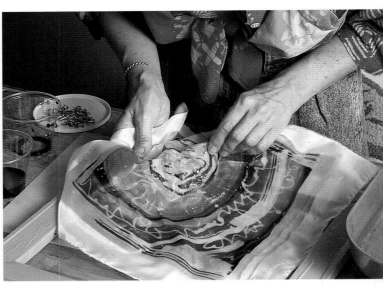

STEP 8. Coat the entire silk surface with wax. Allow to cool. Remove from frame, and gently crackle the wax in selected areas.

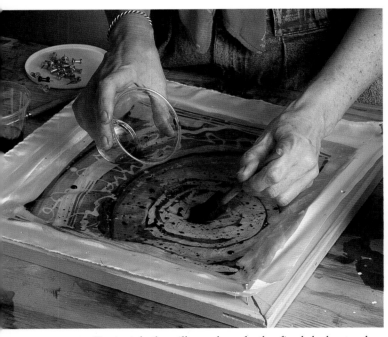

STEP 9. Restretch the silk, and apply the final darkest color. This will seep into the crackles for the distinctive batik look.

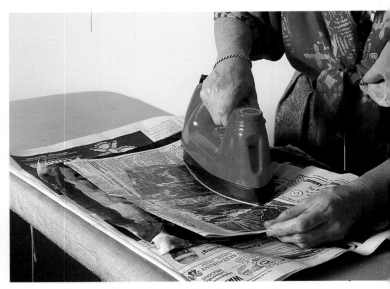

STEP 10. Remove the wax by ironing the silk between layers of newspaper. Keep replacing the paper and ironing it until no wax spots appear on the paper.

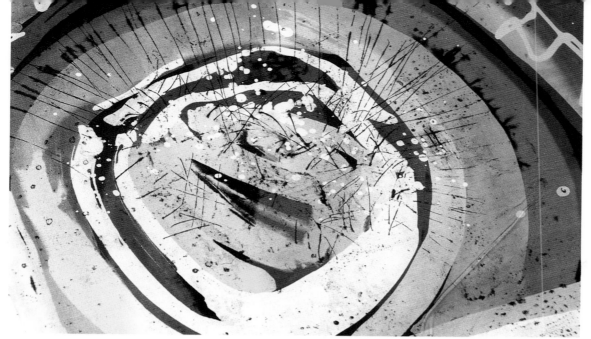

STEP 11. Dry-clean to remove all wax residue and restore the fabric's soft hand. Note the unusual organic effect produced by selective crackling of the wax.

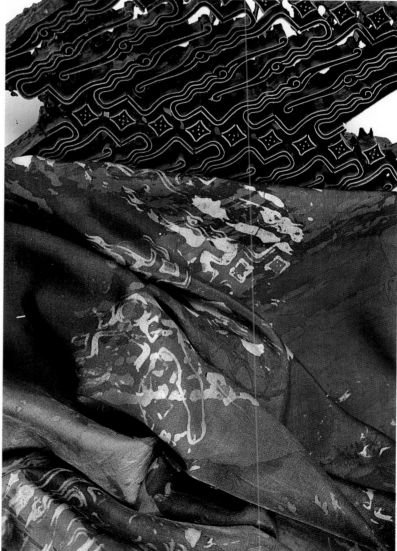

Els. van Baarle (The Netherlands), spun silk yardage (detail), steam-set, fiber-reactive dyes. Photo: Joop van Houde.

The tjap, a traditional Indonesian metal stamping tool used to create these repeated designs with wax, can be fashioned from scrap metal, nails or bolts and held with pliers or mounted on a wooden block.

Jan Janas, *The Big Question* (detail), silk broadcloth, French steam-set dyes.

The interesting dark spots on the green shapes are the result of dye droplets that were not blotted from the surface of the wax after the last dye application. This textural effect adds interest to the flat shapes.

Be careful how much crackling you do. This design was completely overwhelmed by overcrackling the wax.

KATAZOME

Katazome is the most specialized and complex of the techniques discussed in this chapter, but for many silk painters, the results are definitely worth the effort. Katazome involves a resist technique that uses flexible, durable, easily cut stencils and a rice paste resist.

In the traditional method of katazome, you must design "bridges," or connecting links, between the shapes of the design to hold the stencil together as one piece. We found with practice we soon could just draw a design on the stencil paper and start cutting. We didn't need to worry about losing a bridge in the design because, as we worked, new places for bridges occurred naturally. We recommend staying flexible.

If you lose a bridge, work this into the design!

Rice paste resist is an elastic, adhesive resist that effectively holds a very sharp line for dye applications. Traditionally, the rice paste resist is prepared in a lengthy cooking process using rice flour and rice bran. We have found that by using a microwave and a mixer, preparation of the rice paste has been dramatically speeded up.

Traditionally, only natural dyes are used, but with the advent of a wide variety of chemical dyes, the dye process is simplified and broadened. You don't have to size the fabric prior to painting. Simply hand-paint your design, then, when dry, soak the fabric to remove the rice paste.

John Marshall, (detail), katazome yardage, silk noil, natural dyes.

This exquisite yardage illustrates perfectly the traditional Japanese technique, katazome.

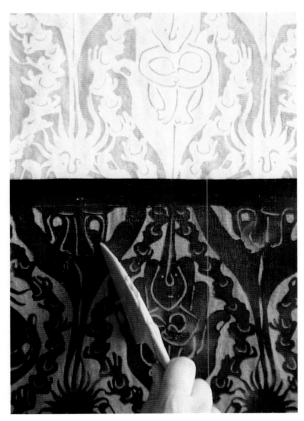

John Marshall, (detail).

Using the traditional process, Marshall presoaks the stencil in water for a half hour, then pats it dry. He places the fabric on a flat surface, positions the stencil on the silk, and spreads rice paste evenly over the stencil with a hara. (You can also use a silkscreen squeegee.)

BLOCK PRINTING

Using a carved plate and an inking medium, block printing transfers designs to a surface through stamping. Modern materials and tools make this process simple and accessible to the average silk painter.

In the past, blocks were carved in hard wood with specialized tools. Our shortcut approach is to carve the design into a rubber-based grouting trowel (found at hardware stores) with a sharp craft knife. Then apply any thickened liquid dye to the "trowel plate" by rolling it on with a brayer or painting it on with a foam brush. Stamp the pattern repeatedly and creatively on your silk surface.

Adhesive-backed sheets of linoleum, available in art and craft stores, can be cut to size and easily carved.

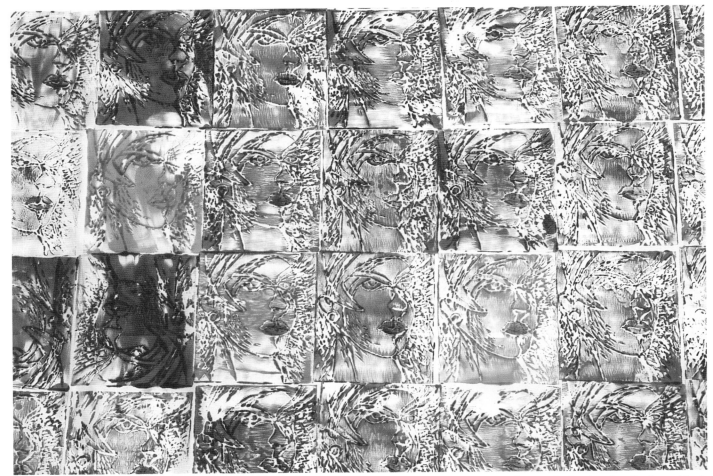

J. Janas, *Face: Colette* (detail), 10mm china silk, 30" × 30", thickened instant set dyes.

Janas accidentally discovered a new look when her linoleum block surface was too slick for the thickened dye to evenly coat the block. The resulting look, though unexpected, created an uneven, yet pleasing, texture.

THE BLOCK PRINTING PROCESS

STEP 1. Dip-dye the silk garment to get a solid background. Stabilize with plastic-coated freezer paper. Coat a brayer with thickened dye or paint, and ink the carved trowel. Stamp the design at different angles.

STEP 2. Embellish the block-printed design, with a commercial fabric paint or a brushed-on dye of a different color.

VARIATIONS. For a varied look using the same block, change color and placement on a new surface. Liquid silk dyes were hand-painted randomly within the open spaces and allowed to bleed. This is a great look for yardage.

SILKSCREENING

This stencil method uses a stretched fabric screen. The printing medium is pulled across the screen and forced through the openings of the stencil so the dye or paint prints the fabric. Silkscreening appeared to be a quick way to repeat patterns, but when we were confronted with the complexity of making the screen, our interest faded. We then discovered that ready-made screens were available in our local art supply store, which quickly revived our interest in this process.

After discussing the techniques and networking with other artists, we came up with some fabulous shortcuts.

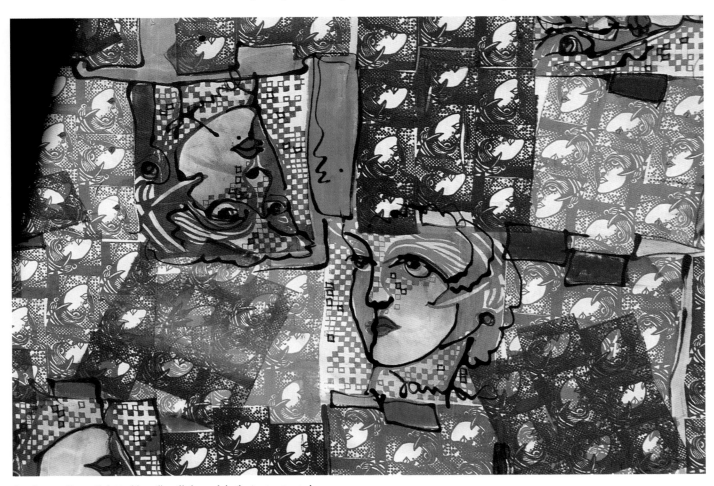

Jan Janas, *Face: Colette* (detail), silk broadcloth, instant set dyes.

This silkscreened fabric was color highlighted with brushed-on thickened dye and outlines of black thickened dye.

PREPARING A SCREEN

STEP 1. First, purchase the screen to determine the size of your design.

STEP 2. Take the design to your local copy center, and have it made into a transparency. Make sure the lines of the transparency are sharp and black.

STEP 3. Look through your phone book for a professional silk-screener, who can burn your design into the screen. You can now have all the fun of silk-screening your fabric the easy way!

THE SILKSCREENING PROCESS

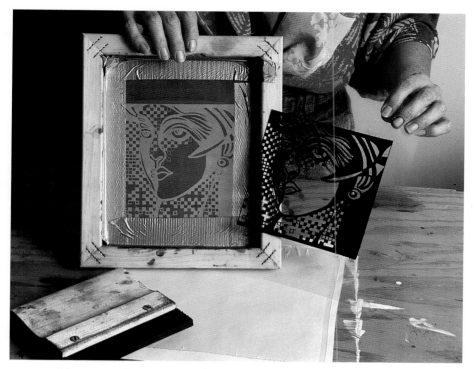

STEP 1. After preparing a screen (see sidebar, left), press three-inch-wide duct tape onto the interior edges of the frame to keep the dye from seeping out as you silkscreen. Force the dye through the stencil with a squeegee.

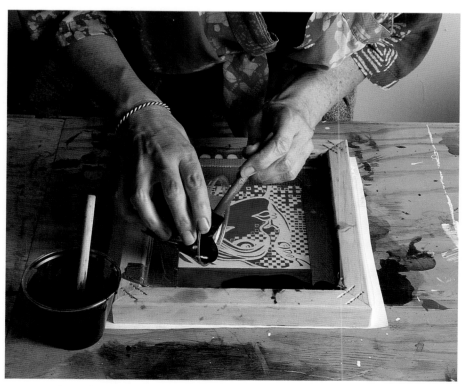

STEP 2. Place the screen over the fabric. Pour the thickened dye over the duct tape at the top of the frame.

STEP 3. Make sure your squeegee is one or two inches shorter than the inside of the frame but wider than your stencil design.

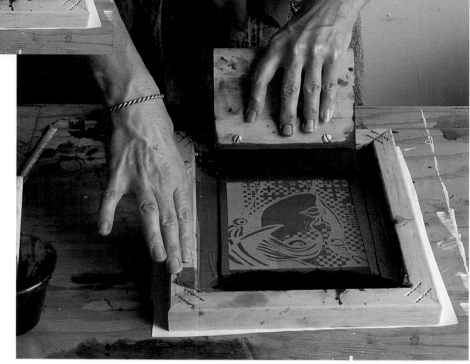

STEP 4. With the squeegee, pull the thickened dye down the entire width of the screen in one firm stroke.

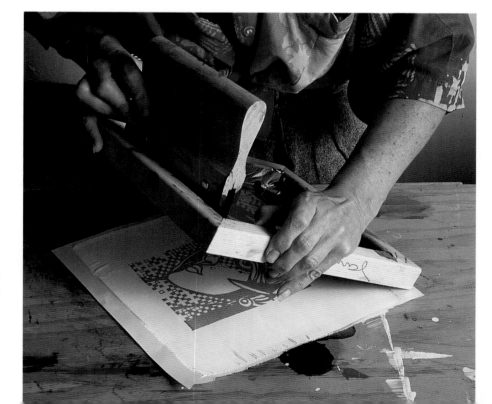

STEP 5. To print again immediately, hold the thickened dye in place at the bottom of the screen with the squeegee. Lift the screen and reposition to print again. Repeat as needed. (Note: Janas makes no attempt to register her designs—that is, have them connect exactly. She just randomly repeats them with a lot of overlaps and color changes.)

Jan Janas, *Ginko* (detail), silk Charmeuse, 36″ × 36″ scarf, instant set silk dyes.

Janas randomly placed this delicate silk-screened design over a mottled background done with a wet-on-wet technique and a foam brush.

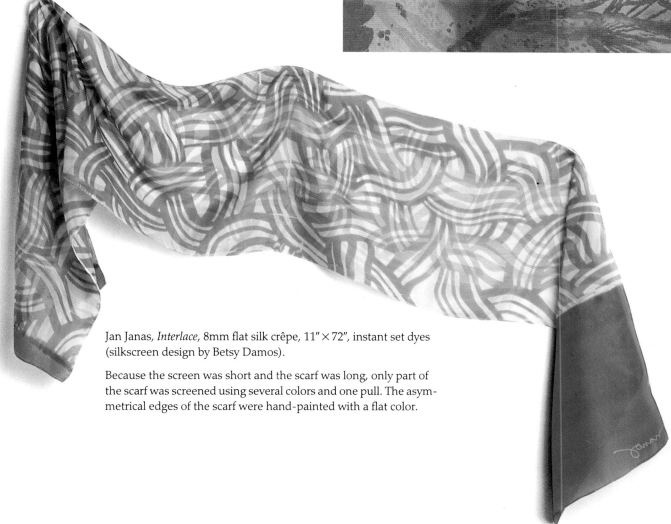

Jan Janas, *Interlace*, 8mm flat silk crêpe, 11″ × 72″, instant set dyes (silkscreen design by Betsy Damos).

Because the screen was short and the scarf was long, only part of the scarf was screened using several colors and one pull. The asymmetrical edges of the scarf were hand-painted with a flat color.

PART THREE

Creating Artistic Attire and Textile Art

PUTTING ON THE ART!

Food and shelter are basic human needs. Clothing follows close behind. From the earliest of times, "fiber arts" played a role in our development. As collective ideas were exchanged, the dyeing and painting of cloth became an important part of various cultures. Decoration, embellishment and enhancement of textiles were very important in establishing social status, age and gender, as well as tribal identification.

Fashion continuously evolves, and while the human body remains the same, the way in which it is covered constantly changes, depending on the individual, the era and the climate. Furthermore, ideas on how to clothe the body are recycled and made fresh as designers use their ethnic backgrounds for inspiration, drawing from art and traditional handcrafts.

Fashion is exciting! It reflects the changes in life-style as it becomes more eclectic. Every time you clothe your body, it enhances your individuality and style. You have the ability to create a whole new image by the way you wear your "art." Witness the importance of fashion and textiles as garments are sought, collected, and displayed in special exhibits.

Fashion expressions have a strong pull: "Come as you are." "Black tie optional." "I wouldn't be caught dead in something like that!" Where does silk painting fit in all this? Simple. The wide-open possibilities of this art form and the fluidity of the surface—silk—offer individuals interested in fashion the opportunity to *put on the art*!

"Artistic Attire," that is, wearable art, means using woven cloth, dye, needle and thread to make a creative artistic statement—a three-dimensional explosion of *moving* art designed to be worn, not just hung. Silk painted garments are art pieces for the body, not just the wall. They have a life of their own! They are adornment embellished with imagination and simplicity or glitz.

When it comes to artistic attire, however, you need *star quality* to carry it off successfully. It can be bold and structured, using strong colors and shapes, and say, "Look at me." Or it can be very subtle, using understated colors (camel, beige, browns, gray and contrasting whites) and loose shapes. Artistic attire can be fun, whimsical, representational, chic, elegant or basic.

Cheryl Pace (Rockford, IL), *Wedding Gown*, silk Charmeuse, Sennelier Tinfix and metallic gold gutta. Seamstress: Kay Reingold.

This dress uses a traditional wedding dress pattern for the top and a Hawaiian holokai for the bottom. Pace and Reingold did a mock-up in muslin to get the correct fit, then Reingold drew out the correct size pattern pieces. Pace did all her designing directly on the pattern pieces and then transferred them to the silk, resisted and painted them. The pieces were then cut out and steamed on the stovetop in a kettle and then sewn together.

Suzanne Wegener (Westmont, IL), *Wrapped Orchids*, sarong-styled skirt, heavy silk crêpe, VisionArt dyes. Designer: Debby Little.

The background leaves were sprayed using the stencil method to achieve a soft airbrush look. Stencils were cut in the orchid motif and stayed in place until the background was finished. The orchid stencils were then removed, and Wegener painted directly on the white areas using concentrated Visionart dyes and sumi brushes in various sizes.

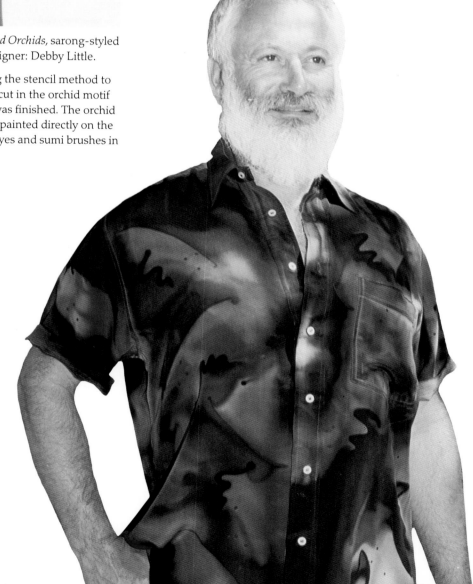

Olivia Batchelder (Laguna Beach, CA), *Man's Silk Shirt*, crêpe de chine, Jacquard dyes, and tinted Silkpaint resist.

Dyes were applied in open and closed shapes and allowed to dry. The shirt was made from shirt blanks with open side seams stretched on a specially built stretcher. They were steam-set, washed and ironed, and then the side seams were sewn up.

78

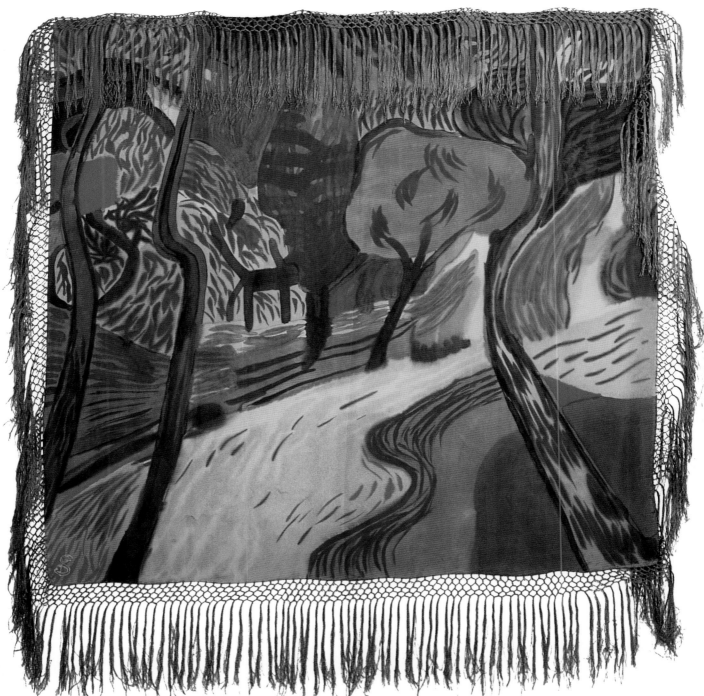

Gunter Schwegler (Cleveland Heights, OH), *Orchard Shawl*, silk, 40″ × 40″ with fringe, Procion dye, alginate thickener.

This Van Gogh-inspired shawl was painted with alginate thickened dyes handled like oil paint and applied with a sponge brush. Much overpainting and blending was used. After steam setting and rinsing, the problem of tangled fringe was corrected by swishing the fringe gently in warm water and hair conditioner.

Jan Janas, *Silk Vests*, jacquard, VisionArt dyes.

If you don't know how to sew, the white silk blanks are the way to go. The design left vest was first outlined with colored, thickened dyes using a metal tip applicator. The open areas were then hand-painted with a brush and then the entire piece dip-dyed. Using a large 2-inch foam brush, Janas randomly painted various greens and blues on the vest (on the right) using wax paper resist for interest. Then the entire vest was dip-dyed in a pale green. The green blouse, a thrift store find, was dip-dyed to match the vest.

Patricia Zastrow (Sun Prairie, WI), *Hua Mia (Pretty Lady)*, crêpe back satin silk, china silk lining, Jacquard dye, Procion dye, Deka resist, metallic thread, polyester fiberfill.

The small line designs were done with colored resist, and the large shapes were painted in with a brush. The vest front was quilted with metallic blue threads and a zigzag stitch.

Jan Janas, *Silk Ties*, Charmeuse, instant set dyes, liquid silk paints, metallic fabric paints, black permanent marker.
To work successfully with pre-made silk tie blanks, use a dye that doesn't need steamsetting or use liquid silk paints.

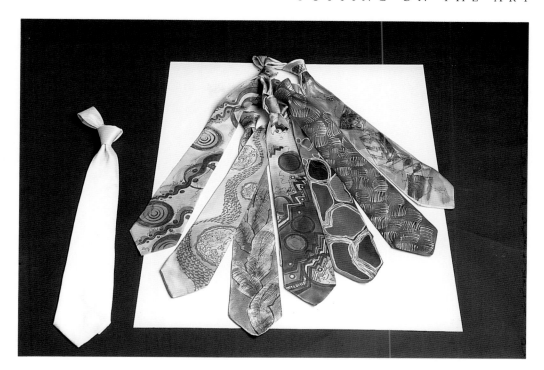

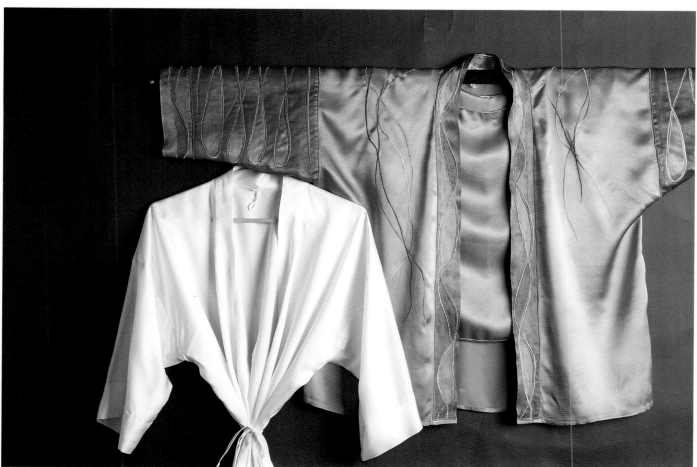

Jan Janas, *Kimono Jacket*, silk Charmeuse, instant set dyes. Quilted by Maggie Backman.

The kimono blanks are wonderful to paint on, especially if the kimono is joined only at the shoulders. This enables you to stretch the kimono out flat. The kimono's sleeves were quilted before painting, then the entire kimono was dip-dyed.

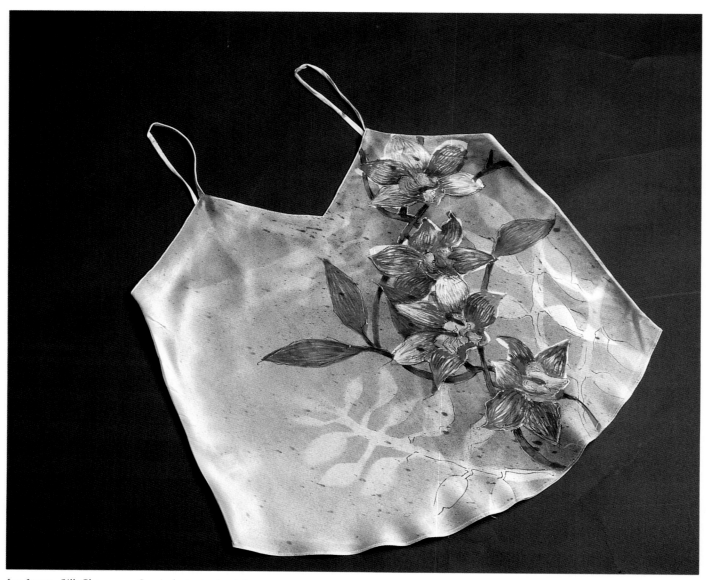

Jan Janas, *Silk Charmeuse Camisole,* instant set dyes.

The design was applied to a blank garment with dye-filled marking pens. Light coats of dye were sprayed on the background over a leaf stencil.

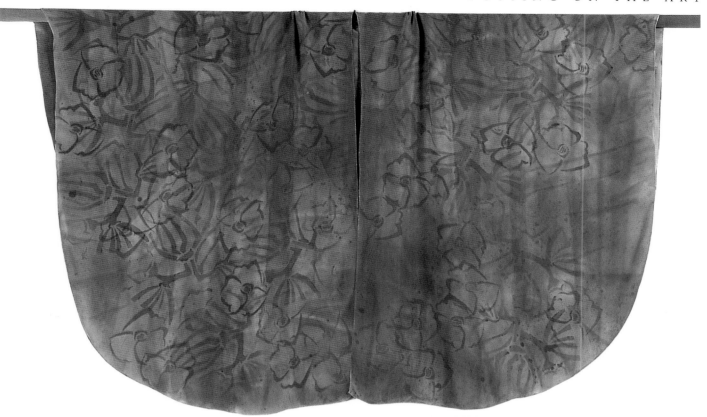

Jan Janas, *Ode to Autumn,* crêpe ruana, instant set dyes.

This is another example of painting a silk blank. The ruana is a versatile garment, worn as a shawl, blouse or skirt. Silk colors don't have to be strong and bold. A little color goes a long way, as in this gentle, subdued autumn design. Janas didn't stretch the ruana; She laid it on a piece of plastic on her worktable, taped down a few edges so it wouldn't move, and, using a 2-inch-wide foam brush, laid out her light base colors. Then she mixed four spray bottles of colors, laid out her stencils and started spraying, moving the stencils around until she was satisfied with the look. Starting with the lightest colors, Janas gradually worked her way to the darkest ones.

Jan Janas, *Ode to Autumn* (detail).

TEXTILE ART IN THE HOME

The tactile qualities of textile art for interior design and home decor are undeniable. It brings special elements into our lives by creating warmth, uniqueness, individuality and personal taste. It is uplifting and calming. Shape, design and color offer high visual impact and delight to a room. Hug a pillow, contemplate a hand-painted screen, and see how it makes you feel!

Your selection of accessories and textile art in a room emphasizes the look you want to achieve. Hang your art at eye level for viewing—low for sitting, higher for standing—and match it to the scale of the room. Drape silk and wool art casually over furniture, or use it as throws. Use banners as free-hanging room dividers that move in the breeze.

Interior designers and homemakers will welcome the opportunity to use your painted fabrics or work with you to produce their own ideas for drapery and furniture coverings.

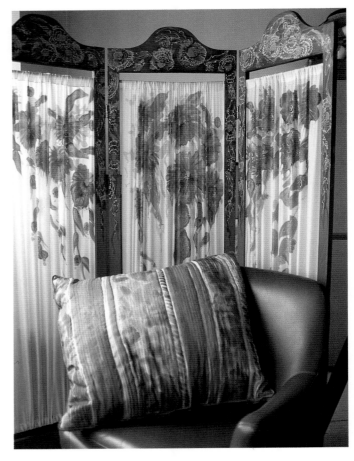

Jan Janas, *Floral Painted Room Divider*, 8mm habotai silk, liquid silk FabricArts paints embellished with metallic fabric paints.

Janas used liquid fabric paints for this room divider and matching pillow because they work on both silk and stain wood. Janas first sanded the wood, then painted it, then sanded it again, then covered it with a clear plastic sealant. Then she threaded three prehemmed silk scarf blanks, one for each panel, onto the rods on both ends of the panel and painted them as they hung.

Julie Ann Cook-Quirk (Brown Deer, WI), *Green Seas*, silk Charmeuse pillow, 16" × 16".

Before painting this pillow, Cook-Quirk applied black gutta. To assemble it, she backed it with black moire taffeta and added a prefabricated black cord trim. The addition of this colorful hand-painted silk pillow, with its colors echoed by the flowers, adds a note of sparkle to this otherwise quiet, conservatively furnished room.

Kathy Owens (Lafayette, LA), *Dreamcloth #2: Meeting of Fire and Water*, silk wall hanging, gutta resist, French dyes, salt technique, 44″ × 71″.

The bright, colorful shapes of this banner project an uplifting, whimsical mood and would add impact and a focal point to any room.

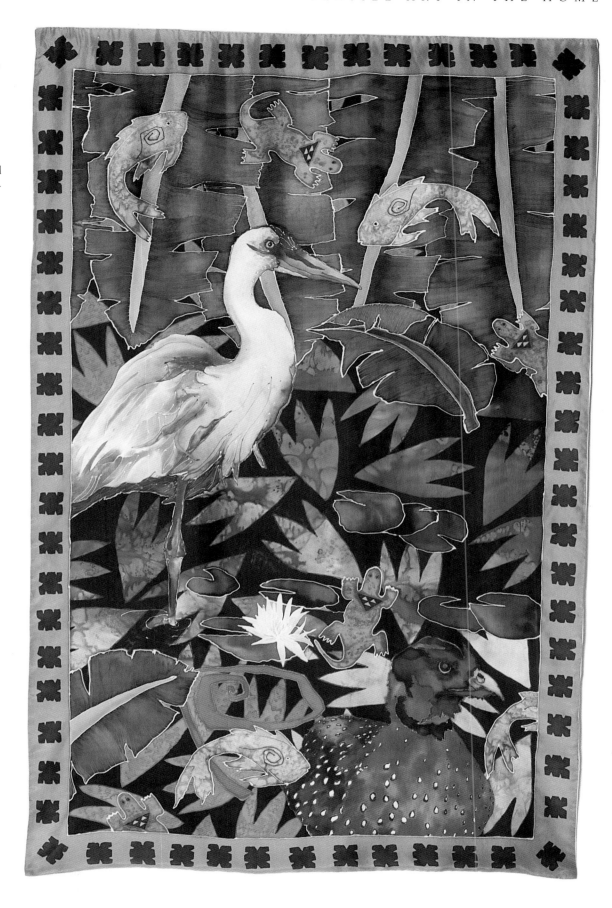

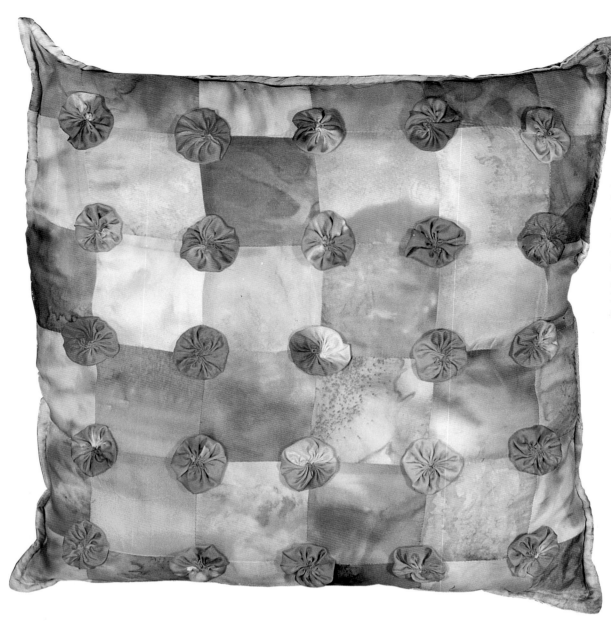

Maxine Kurtzbein (Camas, WA), *Patches and Pinwheels*, 15″ × 15″, Jacquard dyes.

Colorful squares, cut from rejected silk projects, were combined with hand-stitched circular pinwheels.

Jan Janas, *Under the Big Top* (detail).

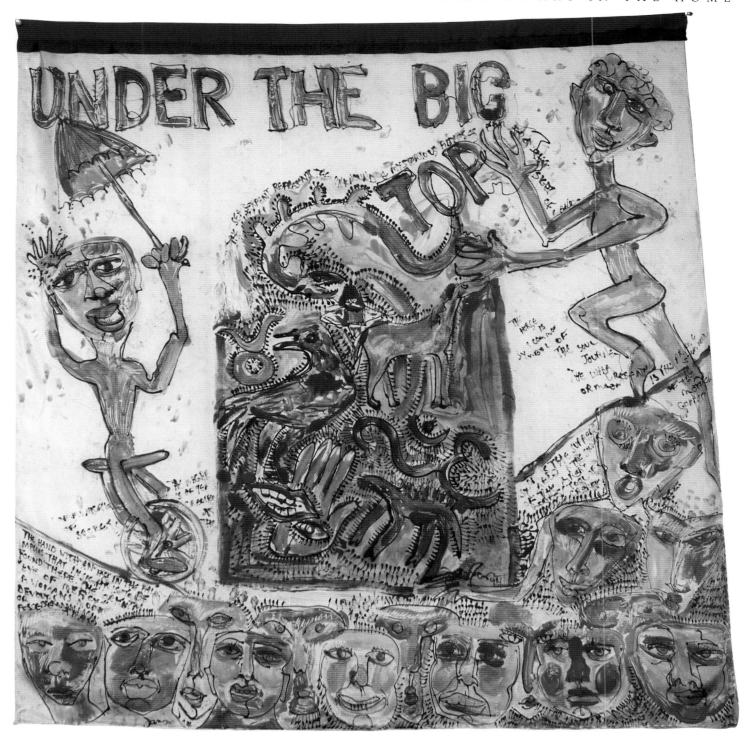

Jan Janas, *Under the Big Top*, 8mm habotai silk banner, thickened VisionArt instant set dyes, 40″ × 40″.

In this child's room art featuring multiple monoprints, the theme is light, airy and fun, with lots of action. Janas drew her design with thickened dyes onto an 18″ × 24″ acrylic (plastic) sheet. She then pressed the painted plastic onto the silk. Since the plastic was considerably smaller than the silk, she created the composition in bits and pieces. After it was finished, Janas put black thickened dye into a metal applicator and wrote words and stories and drew outlines where she wanted greater definition.

PAINTING YARDAGE

Painting yardage can be quite intimidating because of its scale. You are confronted with a large white surface; a different mind-set is required when visualizing design and color on such a scale. Painting yardage necessitates space, equipment, and an investment in planning time, painting time, fabric and dyes. It only takes *one* experience to uncover the mysteries of painting large surfaces. What seem to be major obstacles become exciting processes. All it takes is the courage to try.

Why paint yardage? Because it can be used to produce "one-of-a-kind" art to wear and banners or panels for architectural textile art and home decor. Unusual artistic yardage is often commissioned by fashion designers for their collections. And best of all, because of the many practical applications, it can be quite lucrative.

We will focus on how to paint yardage for artistic attire, but this information also works for painting banners and panels. Think about the variables below before starting.

- **WORKSPACE** You must have enough room to access the painting surface from all sides. Good lighting is critical, as are easy access to water, electrical outlets, and a well-organized area for containers, dyes, paints and tools. Set up a workspace that works for you.
- **END USE** Is the fabric commissioned, or is it for your use? Will the project be duplicated, and is it large (over 3½ yards), medium (1½ yards to 3½ yards), or small (1 to 1½ yards)? The style of the garment will also determine the choice of fabric, technique and product.
- **FABRIC** Select a fabric that suits the climate, social event, fashion pattern, and personality and budget of the wearer.
- **DYES** Check whether your dye is fiber specific. Is the dye readily available? Does it require any setting, and if so, do you have the facilities to process the fabric? Take the time to become familiar with the product of your choice before committing.
- **TECHNIQUES** Choose techniques that fit your level of expertise. Is the desired look conservative, exotic, wild or zany? Does your design require only the use of a single technique or several? Select techniques that are suitable to the size of the project. Deadlines and time restraints may limit your choice of technique.

After weighing these factors and making choices, follow the general procedures outlined. Maintain your flexibility and, most of all, adapt to your circumstances and your project.

Selecting the Right Technique

Choose the technique most compatible with the fabric and its use. Although many time-consuming techniques are worthwhile and make your work unique, you must decide if you want to devote time to them. Your ability to choose the appropriate techniques for your experience level will showcase your talent and abilities. Here are some techniques to choose from and their difficulty levels:

SUPER FAST AND EASY
- Salt (use with dyes and paints, not with instant set dyes, for a starburst effect)
- Alcohol and water spotting (use with unset dyes, but not instant set dyes)
- Wet-on-wet
- Wet-on-dry backgrounds
- Striping

QUICK AND EASY
- Texturing with foam brushes and other tools
- Spraying
- Layering
- Immersion dyeing for flat backgrounds
- Tie-dye effects
- Stenciling
- Stamping
- Block printing

MODERATELY EASY
- Resist with or without applicators
- Markers
- Pens
- Large freehand designs
- Antifusant (apply to fabric before painting for nonflowing effect)
- Thickened dyes
- Sugar syrup
- Fabric paints for embellishments

MORE INVOLVED
- Batik
- Sgraffiti
- Detailed resist work
- Silkscreening

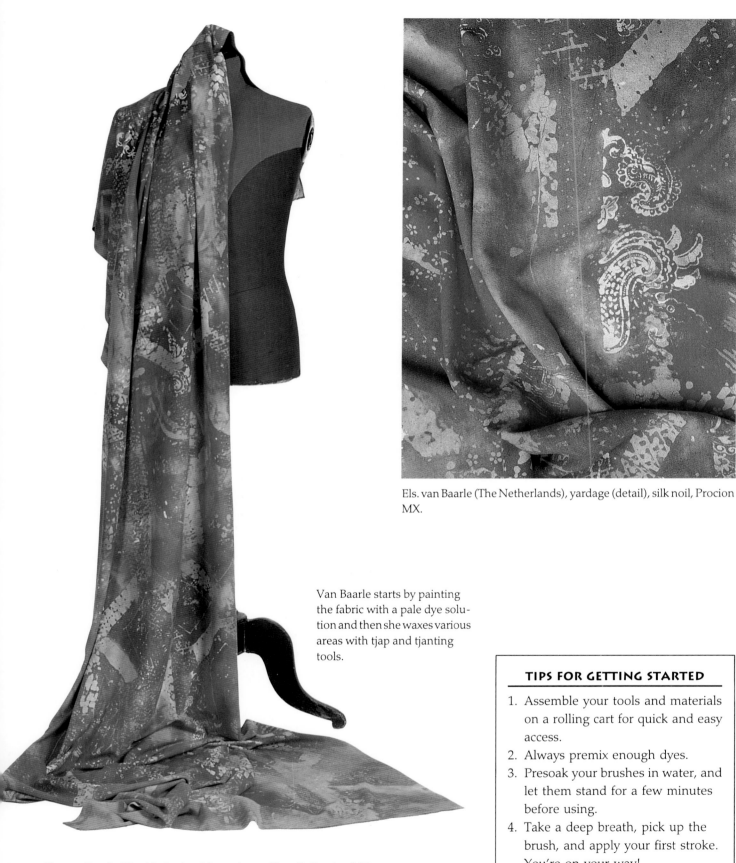

Els. van Baarle (The Netherlands), yardage (detail), silk noil, Procion MX.

Van Baarle starts by painting the fabric with a pale dye solution and then she waxes various areas with tjap and tjanting tools.

Els. van Baarle (The Netherlands), yardage, silk noil, Procion MX.

TIPS FOR GETTING STARTED

1. Assemble your tools and materials on a rolling cart for quick and easy access.
2. Always premix enough dyes.
3. Presoak your brushes in water, and let them stand for a few minutes before using.
4. Take a deep breath, pick up the brush, and apply your first stroke. You're on your way!

Stretching Fabric

Set up a stretching frame over two sawhorses. Purchase four 1" × 4" soft knot-free wood boards, such as pine: Two should be as long as the width of your fabric plus 15" and two as long as the length of the fabric plus 15". Use two 6" C-clamps to hold the short boards onto the sawhorses. Use four 3" C-clamps to secure the long boards over the short boards at each corner. (Many other types of frames are available.)

PREPARE THE SILK

Cut or rip the selected silk. Wash the fabric in a prewash and rinse well. If you're using instant set dyes, you can dip the fabric in the soaking bath before stretching; this improves bondability. Fabric can be stretched damp or dry. Iron the fabric if you will stretch it dry.

STRETCHING THE FABRIC

Use pushpins, a heavy-duty staple gun or three-prong tacks to secure the fabric to a frame. Stretch the fabric tautly as you pin it. Securing the width is optional. Keep the fabric straight so the warp and the weft are at right angles. While you are painting, your fabric will often sag. Correct this by loosening the two C-clamps on one long side of the frame, and slide the board out until the fabric is taut again. (This is what the extra 15" are for.) Retighten the C-clamps.

Whether or not you stretch your silk is influenced by the technique(s) you're using. The most creative surface designs on fabric often involve stretching or stabilizing the silk in various unconventional ways. Stretching and restretching can be done several times at various intervals of the process.

One practical stretching frame for a large space uses sawhorses, C-clamps and 1" × 4" boards.

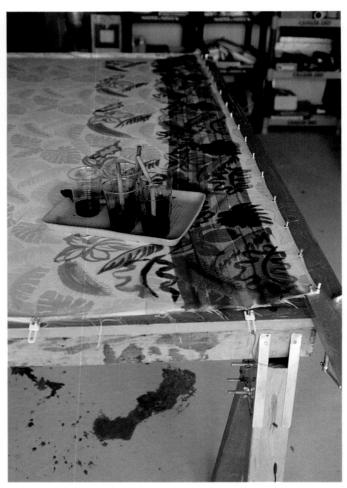

Here, Janas painted the fabric on a frame, then cut it into pieces for a skirt.

TIPS FOR STRETCHING FABRIC

You do not always need to stretch your fabric or use a frame. The following suggestions are just that, suggestions about and alternatives to stretching or not stretching.

- Use the sawhorse frame if you are resisting intricate designs, doing detailed brush work, layering or spraying. This frame also provides you with an inexpensive working area that is large enough for your project whatever the size. Place a light and a design underneath if you find it helpful.

- Spread silk over white plastic sheeting placed on the floor or table if you are using techniques that involve splattering and unstructured color applications.

- Use a padded table for stamping, silkscreening and block printing.

- For immersion dyeing, dip your fabric in a tub or bucket.

- For simple striped effects and for dribbling, paint outdoors with the silk draped over a clothesline. Painting in the shower is also an alternative. Beware: the dye may stain porcelain.

- Stabilize the fabric by ironing it to freezer paper (see page 54), and then paint on a table or the floor.

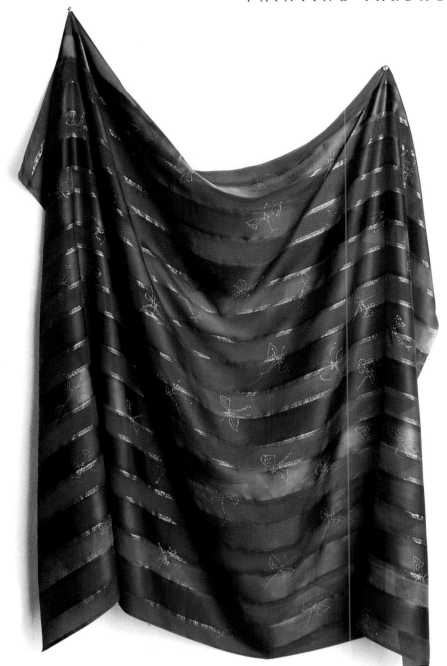

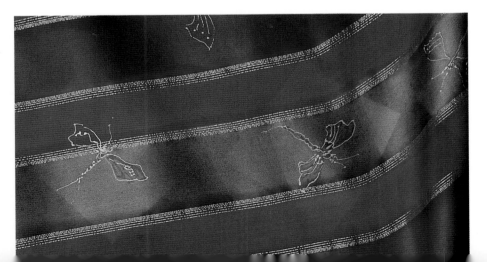

Jan Janas, *Dragonflies*, yardage, ribbon chiffon with gold thread, instant set dyes.

After stretching the fabric, Janas mixed six cups of different colors using an analogous color scheme and put a 1-inch foam brush in each cup. She picked up a cup with a brush and painted a stripe, then returned with the next cup of color and painted another stripe, alternating colors until she was finished. When it dried, she stencil-sprayed the final detail, the dragonfly, onto the silk.

Using a Pattern

Pin the garment pattern to the fabric. Use a fabric marking pencil to lightly outline the shapes, leaving ¼" of extra fabric all around to allow for any stretching distortion. Outline each pattern piece with a wide line of resist. If the fabric is heavy, be sure the consistency of the resist is thin enough to penetrate.

Pin the pattern to the fabric, trace the pattern with pencil, then go over the pencil lines with a gutta resist.

TIPS FOR WORKING WITHOUT A PATTERN

If you're painting fabric to be sewn into a loose garment without the use of a detailed pattern, here are a few ideas:

1. Fold the fabric in half length-wise, and place straight pins along the center line; this eliminates the need for pencil lines. Use this approach if you need to mark off areas that must match after painting.
2. When painting wide smooth backgrounds, work with a friend and paint from opposite directions, meeting in the middle.
3. You can also paint the background by dip-dyeing the fabric (without a friend!).

TIPS FOR CARING FOR PAINTED SILK

- Remember that hand-painted garments are not designed to be washed frequently. Hand wash or dry-clean only.
- Avoid water that is chlorinated or alkaline.
- Use a large container and plenty of water to quickly wash the silk.
- *Never* use detergent; use neutral soaps, such as baby shampoo.
- Air the garments after each use.
- Never soak the fabric.
- Never use bleach.
- Store them away from light, sun and heat.

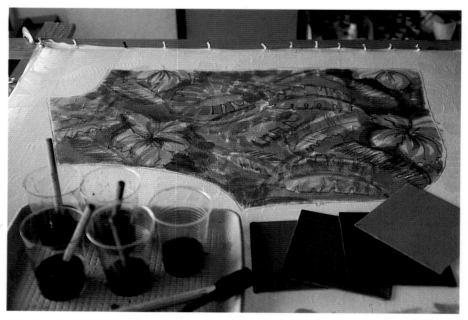

This free-flowing design was painted within the resist lines of the vest pattern piece with instant-set dyes.

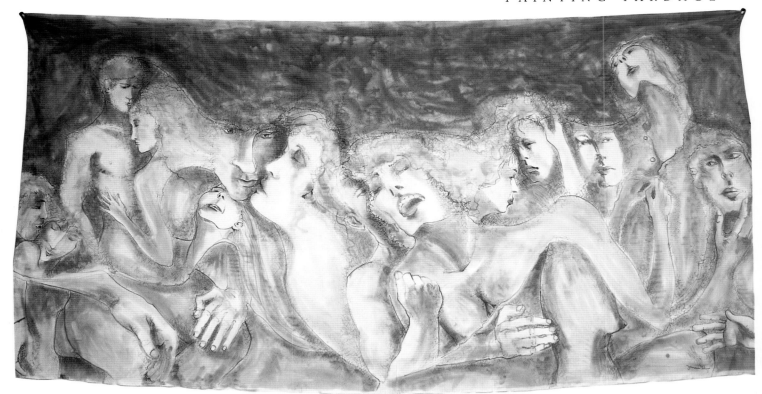

Jan Janas, *Oh, Johnny!*, 10mm china silk, unlined wall hanging, 108″ × 52″, instant set dyes.

Janas layered the flesh tone color in a painterly style, letting the light tone of the silk add a lifelike quality. She added textural detail with a no. 12 round brush and line work with a permanent marking pen.

Painting Yardage with Various Techniques

Pretesting before you start is a *must*. Set up a small frame, make a sample using the identical fabric, dye and techniques you intend to use, and go through the entire process, including setting and rinsing, before you commit to yardage. It will give you the confidence to start on that large white canvas, your fabric.

Although you have a plan, we cannot stress enough the importance of remaining flexible at this point of the process! Do not fight it. Allow your creativity to *flow*, as the art you are producing has a life of its own. When you are finished, leave it stretched, stand back, and look at it critically a day or so later. You might wish to make changes. Sign your yardage several times, because you'll be cutting it.

SETTING THE FABRIC

Set the fabric if the dye requires it. Rinse to remove any excess dye (see page 17), and iron while damp. You may wish to dry-clean the fabric if you used gutta or wax resists or very heavy fabrics, such as wool, brocades and satins.

When your yardage is finished, you will experience incredible satisfaction. You have taken your vision from its inception to the reality—a completed work of art. You have learned that you are not confined to any one look but can produce one-of-a-kind fabrics with unusual designs and color schemes that might cost a fortune to buy.

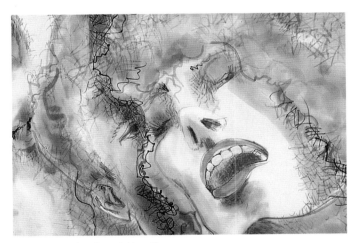

Jan Janas, *Oh, Johnny!* (detail).

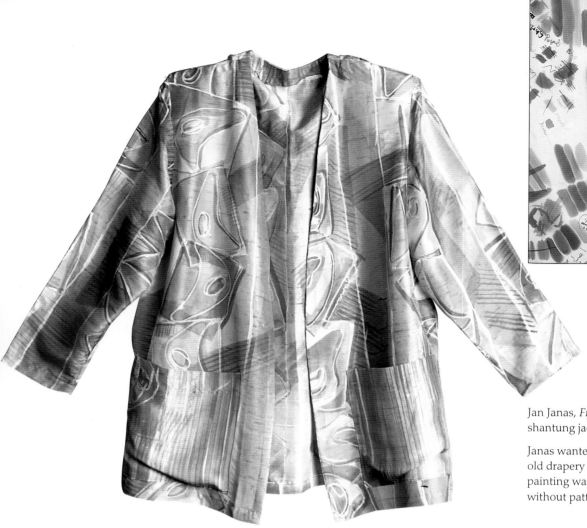

This practice fabric for *Fifties Revisited* was used to test colors and color combinations for the yardage.

Jan Janas, *Fifties Revisited*, unlined silk shantung jacket, instant set silk dyes.

Janas wanted this basic jacket to resemble old drapery fabric from the 1950s. The painting was done on stretched yardage, without pattern outlines.

Jan Janas, *Fifties Revisited* (detail).

The quick and easy techniques used on Janas's jacket included stencil spraying, resisting and brushing.

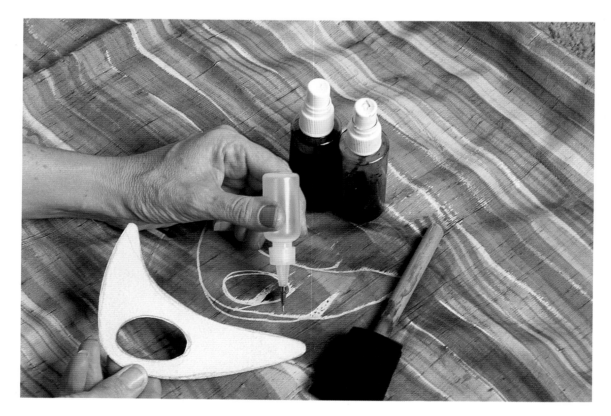

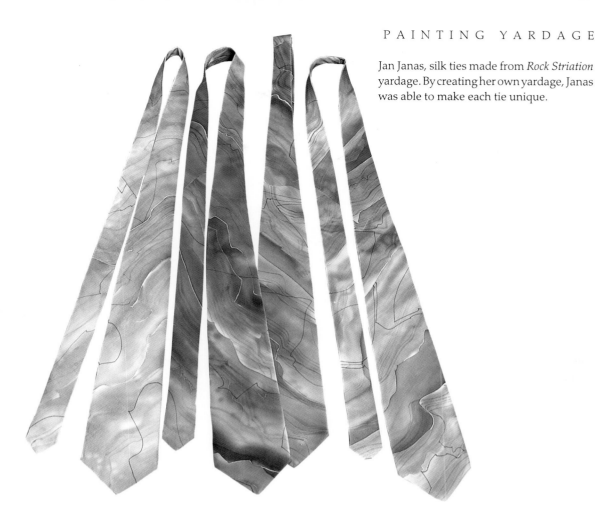

Jan Janas, silk ties made from *Rock Striation* yardage. By creating her own yardage, Janas was able to make each tie unique.

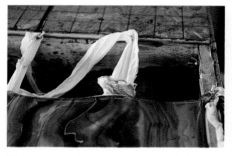

This yardage for ties was too small for the frame opening, so to stretch it, Janas pinned strips of fabric to the silk and pushpinned them into the large frame.

Jan Janas, *Rock Striation* (detail), 19mm silk Charmeuse, fabric paints with permanent black marking pen and gutta resist.

Janas resisted the wavy horizontal lines with clear gutta using a metal-tip applicator, and painted wet-in-wet with a 1-inch foam brush. She worked back into the lines with a round watercolor brush and striped in thin lines. The black lines were added randomly, a la Mother Nature.

QUILTING AND EMBELLISHMENTS

Quilting, embellishment and ornamentation are part of the biggest up-and-coming artistic expression in fiber and textile arts. With experimentation, you can combine many of these effects with your own painted attire or home decor art.

Quilting

The possibility of customizing colors is a big plus. Painting a whole cloth silk quilt, that is, one large piece of fabric, and then quilting without piecing is quite a thrill and a challenge. Dye silk threads, ribbons and bias to add excitement. Play with embroidery, stamping, embellishments and applique.

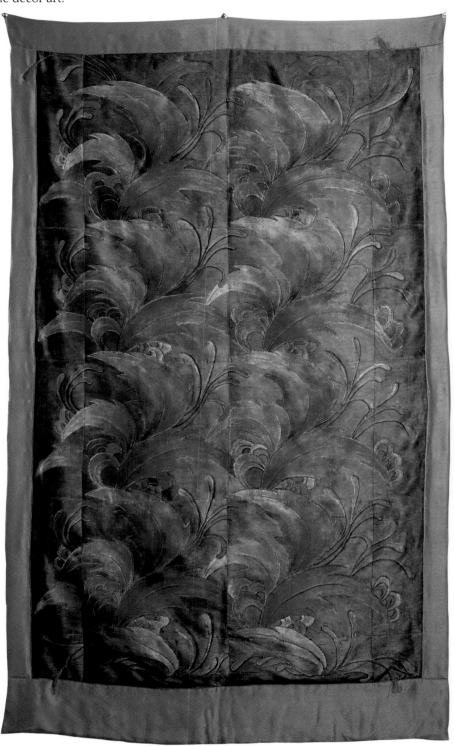

Jan Janas, *Dancing Leaves*, silk shantung with silk batting, 36″ × 52″, VisionArt instant set silk dyes.

QUILTED BEFORE PAINTED

This was a collaborative piece between the artist and the seamstress Maggie Backman. Janas designed the silk pattern and Backman, following the pattern, sewed the unpainted quilt together except for the backing. Janas then painted the front of the quilt and dip-dyed the backing, which Backman then attached to the quilt front.

Jan Janas, *Dancing Leaves* (detail).

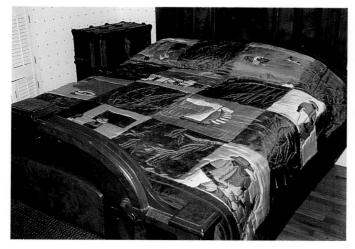

Kerry Kilien McCarthy (Leavenworth, Kansas), *Caribbean Quilt*, silk twill, 80″ × 80″, steam-set silk dyes outlined in black gutta.

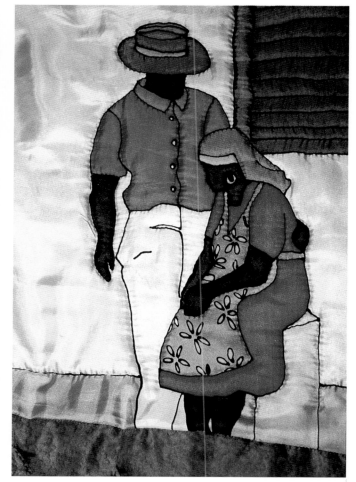

STITCHING FOLLOWS OUTLINE

This quilt features panels of textured green and scenes of island life adapted from photos from a recent vacation. Notice how the black quilting stitches follow the black gutta outlines.

Kerry Kilien McCarthy, *Caribbean Quilt* (detail).

Embellishing

Ribbon, ribbon everywhere! Custom dye silk ribbons in many different ways by dipping, hand-painting, and designing with brushes and markers. Dye or hand-paint premade silk roses and accessories. Use the sequence dyeing method or the wicking technique to dye ribbon. The 2"-wide ribbon is the easiest size to dye because it wicks best. Roll into a flat cylinder and set to wick.

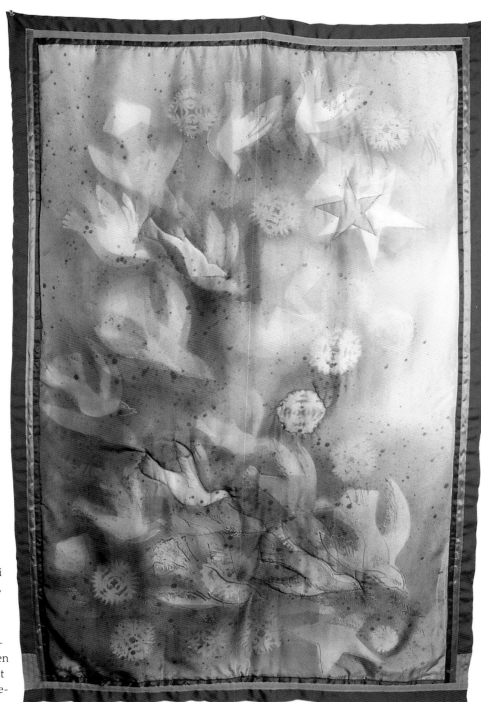

Jan Janas, *Christmas Quilt*, 10mm habotai silk, 36" × 46", VisionArt instant silk dyes, polyester batting.

SILK RIBBON BORDER

This is a "whole cloth quilt" with a three-ribbon border. It's easy to make a quilt when you stretch out a single piece of silk, paint it, and then machine quilt the pattern in selected areas. Finishing it off with a custom dyed ribbon border makes an elegant and personal statement.

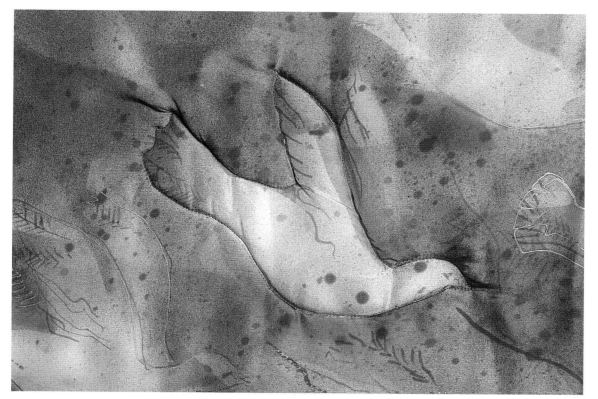

Jan Janas, *Christmas Quilt* (detail).

STENCIL TECHNIQUE

This quilt was painted with four spray bottles filled with VisionArt dye and four stencils. The stencils were sprayed in layers, starting with the lightest colors. First the yellow was sprayed, then the stencil was cleaned off and moved. The same was done with the next three colors until the entire piece was filled with colors and patterns. The last touch was outlining selected areas of the design with metallic paint in a metal tip applicator.

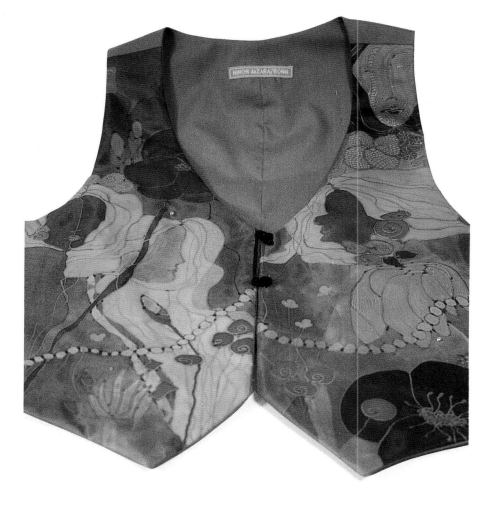

Ninon deZara/Ronn (Roxbury, CT), *Keepers of the Way*, silk vest, steam-set dyes and metallic paints.

DECORATIVE EMBELLISHMENTS

The vest was embellished with embroidery elements, appliqué and nailheads. The motif is repeated on the back of the vest with fantasy flower appliques.

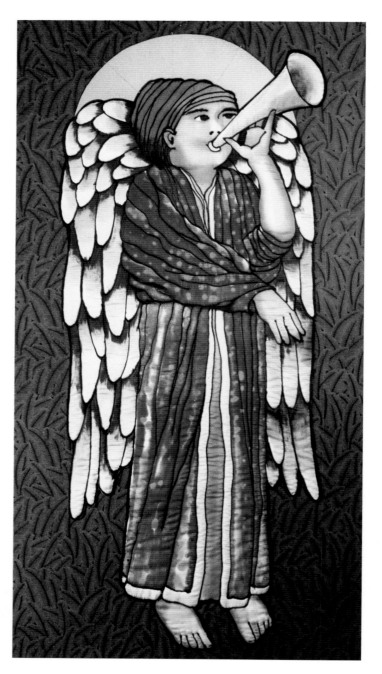

Margaret Agner (Athens, GA), *Piper*, 8mm habotai silk, 18″ × 36″, fiber-reactive dyes and Createx pure pigment medium.

APPLIQUÉ AFTER QUILTING

Agner outlined the figure in black paint, then painted on the colors with a bamboo brush. After steaming and washing the silk, she quilted it along the black painted lines. The silk figure was appliquéd onto printed fabric. The finished work was stretched over canvas stretcher strips.

Costuming

Using custom-mixed colors, refurbish old silk costumes without taking the garment apart, using the instant set dyes. Make Victorian flowers and use dyed ribbon for the rusching (gathered) ribbon technique. The instant set dyes are excellent for pleated ribbon and antique ribbon embroidery. Variegate the ribbon by sequence dyeing for your own color scheme.

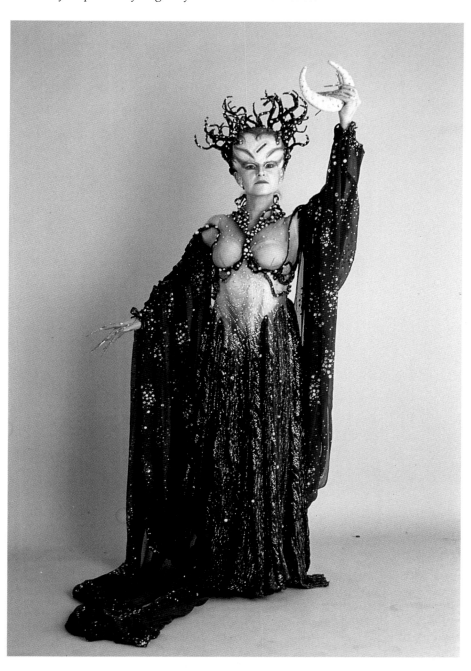

Judy Smith (Spring Green, WI), costume for Santa Fe Opera performance of *The Magic Flute*, silk organza, satin organza, silk chiffon, silk velvet, VisionArt instant set dyes.

Instant set dyes work well where time and facilities are limited (as for theatrical costumes) because the colors are intense and there's no need to steam-set the dyes.

Embroidery

Silk painting with its delicate shadings, unusual colors or subtle blending is a way to prepare sophisticated backgrounds for hand and machine embroidery as well as beading. And now with the instant set dyes, the threads can also be custom dyed or painted right on the cloth.

Jan Janas, *Long Vest*, shantung silk and silk thread embroidery, VisionArt instant set dyes.

MACHINE EMBROIDERY

This vest was hand-painted and dip-dyed and then machine embroidered on top of the pattern.

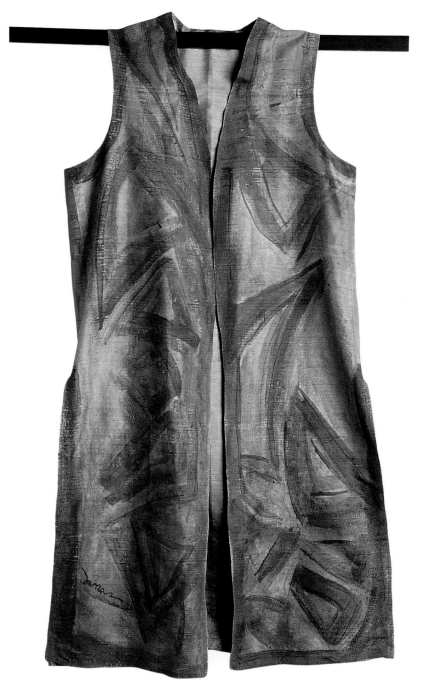

Weaving and Mixed Fibers

Combining different types of fabric is another way to create unusual and distinctive fiber art. Silk, with its sheen and delicate texture, is perfect to contrast with the rough, thick texture of wool.

Consider dipping silk and wool yarn and fibers to custom dye them for weaving. Spin silk and wool together before dip-dyeing with instant set dyes. This creates a variegated effect because the dye bonds to the two fibers at different speeds. Try warp painting with the instant set dyes directly on the loom to save time.

Elizabeth Anyaa (Helsinki, Finland), hat (6″ × 9½″) and neckpiece (10″ × 3½″), Jacquard silk and felt, steam-set dyes.

CONTRASTING FABRICS
In this piece, Anyaa wanted to contrast two fabrics, silk and felt. By the way the fabrics took dyes, she was able to emphasize the softness of the silk and the strong, textural quality of the wool felt.

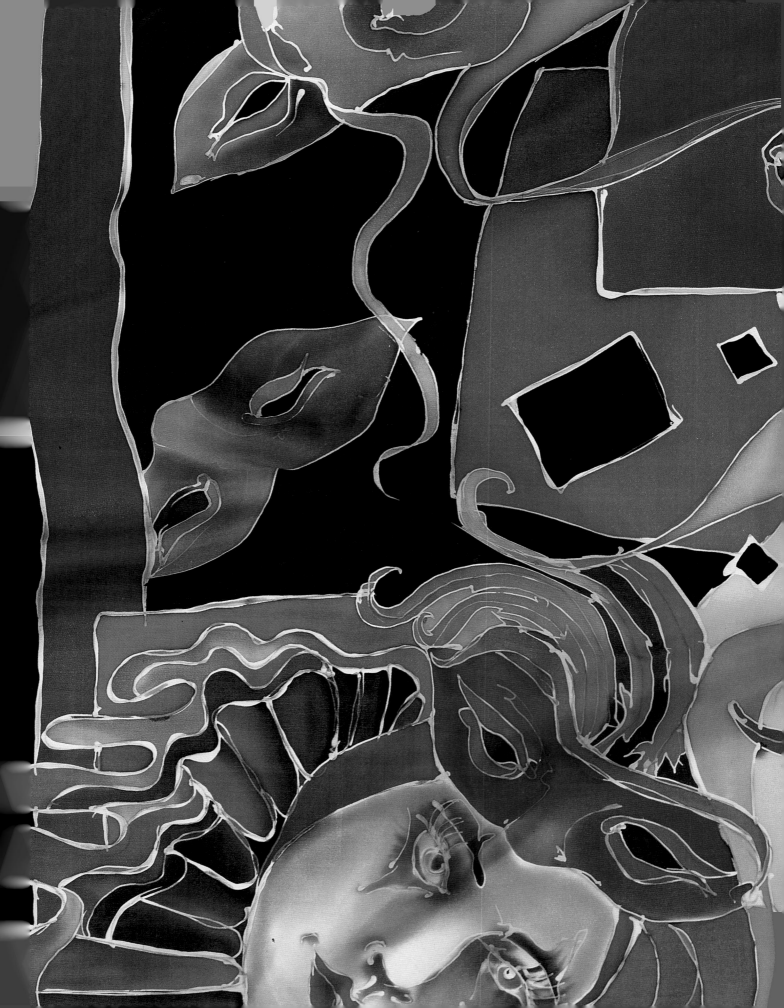

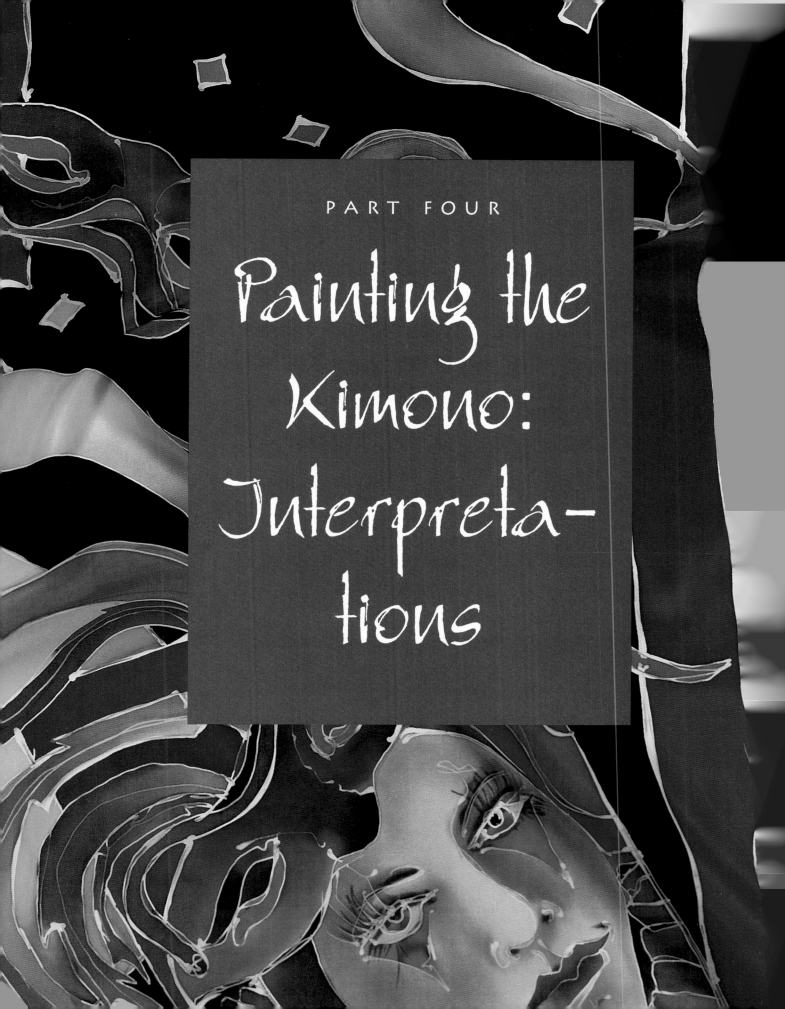

Painting the Kimono: Interpreta- tions

PAINTING WITH THE PROS

For this unique gallery, rather than working with just paintings on fabric, we invited a group of artists to design and paint on one of the oldest, most traditional art forms today, the kimono. This simple garment, which literally means "thing to wear" or "clothing," has had a long history.

The kimono is unique to Japan. Like so many other ancient Japanese artistic forms, such as ikebana (flower arranging) and origami (paper folding), the kimono reflects the basic tenets of Japanese culture: love, respect, beauty, harmony and sensitivity to nature. Though no longer commonly used in

modern-day Japan, kimonos are still seen at weddings, temples and New Year celebrations.

Kimono fabrics and designs varied with the season and climate. In colder climates, kimonos were made of wool or layered or quilted fabric. Kimonos were also worn in layers, each having its own significance. Although kimonos are made of many natural and man-made fabrics, in this book we will only discuss kimonos made of silk.

The simple, distinctive, straight T-shape of the kimono serves as an ideal "canvas" for artists, which probably ac-

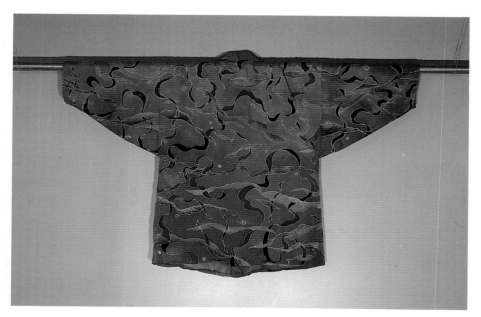

Kaori Takami (Nishinasuno, Tochigi, Japan), *Passion*, kimono, Tinfix dye on silk.

Resisting first and then painting, Takami incorporates an uneven fabric hemline and sleeve line to emphasize the repeated floral shapes. Her limited palette of analogous colors creates exciting movement within the kimono design by variation in intensity of the hues.

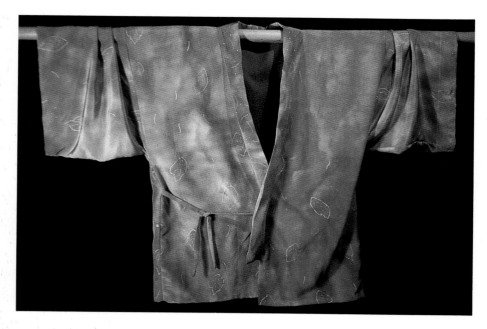

Angelia Armstrong, Armstrong Design (Hampton, VA), short oriental jacket, crêpe de chine with rayon lining.

Patricia Hable Zastrow (Sun Prairie, WI), *Desert Celebration*, crêpe back satin silk coat with china silk lining.

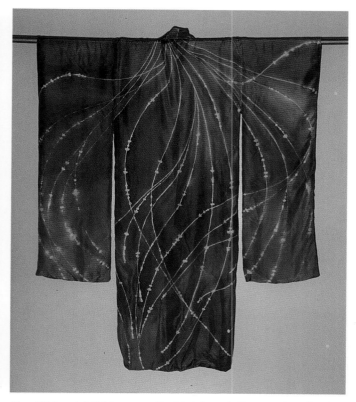

Kaori Takami (Nishinasuno, Tochigi, Japan), *Tempura Noodles*, kimono, Tinfix dye on silk.

counts for its popularity in the "wearable art" movement. As an art form, the kimono is sculptural (three-dimensional), with a sense of timelessness.

Throughout this book and our first book, *The Complete Book of Silk Painting*, we discussed specific, individual silk painting techniques. In this section you will see what happens when these techniques are combined in various layers, in varying orders, or used in individual, often unique, ways by many different artists. Seeing how so many different artists work will give you a sense of the range of finished effects you can get by combining techniques. You will also observe the effect of layering various techniques in order to create unique, individual garments—and paintings, too, for the kimono is just one more "canvas" for your art. Thus, this section represents a theme and its variations, showing how many different looks can result when a group of professional silk painters are "let loose" to work within a simple, traditional shape.

It is important to understand that even though these artists are using the same surface and techniques, it's the techniques they choose to use and how they superimpose or combine them that creates their own personal look. To give you more insight into the way they work and the final effects of their combination of simple techniques, look at the close-ups of

their work and read how they created their individual looks.

Also take note of the tremendous variety within the original kimono shape: The sleeves can be winged, tapered, squared or nonexistent. The coat can be long or short. The look can be formal or whimsical. Designs can be traditional, abstract, geometrical or figurative. The fabric can be painted, quilted, and embellished with beads, ribbons, buttons and other objects. Seams can be bound, and edges can be ruffled. The kimono can be lined or unlined. It can be machine or hand sewn. The outside can be painted in many ways—but so can the lining.

The kimonos are grouped according to the final overall effect, with sections that show kimonos with geometrical forms and spirals, a traditional Japanese look, natural forms and whimsical designs. Each caption for a kimono in this section describes the techniques used by the artist. And, for most images, a close-up is supplied that magnifies the techniques and focuses on the details so you can see these techniques in action.

In short, this gallery, with its range of interpretations, is designed to inspire your creativity. We hope that after seeing what these artists have done, you will take bits and pieces of ideas that attract you and adapt them to your own style.

SPIRALS AND GEOMETRIC SHAPES

Spirals and geometric shapes are basic, ancient symbols found in all art. Notice how interesting and varied these simple kimono shapes can become with the use of geometric designs.

Terry Higgs (Tulsa, OK), crêpe de chine kimono.

Diluted VisionArt dyes were sprayed around spiral-shaped stencils to create the intricate pattern on the light-colored sleeves, pockets and collar.

Peggotty Christensen, Peggotty
Handpainted Silk (Phoenix, AZ), crêpe de
chine dress, chiffon/georgette kimono coat.

These crêpe de chine designs were painted
into the fabric with Procion H dyes. Line-
work was done with a water-soluble resist.
The designs in the turquoise-colored area
were discharged with Presist.

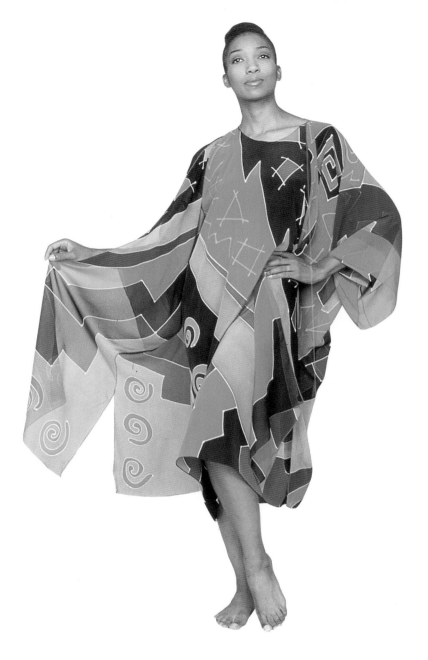

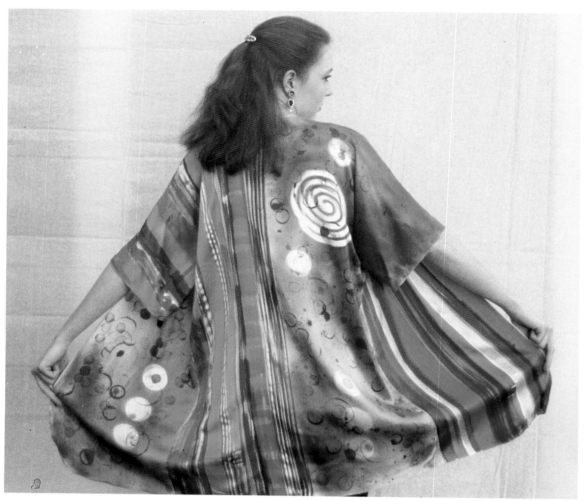

Beverly Rogers-Gaynor (Gulf Breeze, FL), *Celestial*, silk Charmeuse kimono.

The artist first sprayed many layers of VisionArt dyes over the circle and spiral-shaped stencils. She then stamped in various-sized circles and dots. The stripes were applied with a 2-inch sponge brush that had nicks cut into its tip for contrast in width size of the stripe. Since the dye sets instantly, this garment was not steamed.

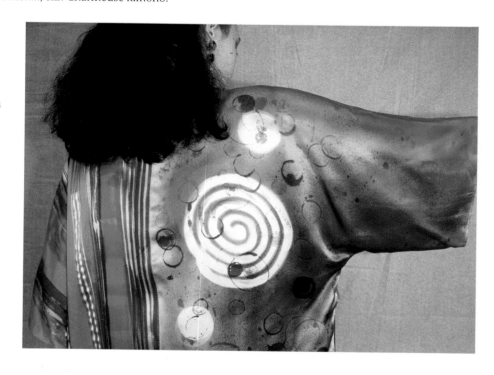

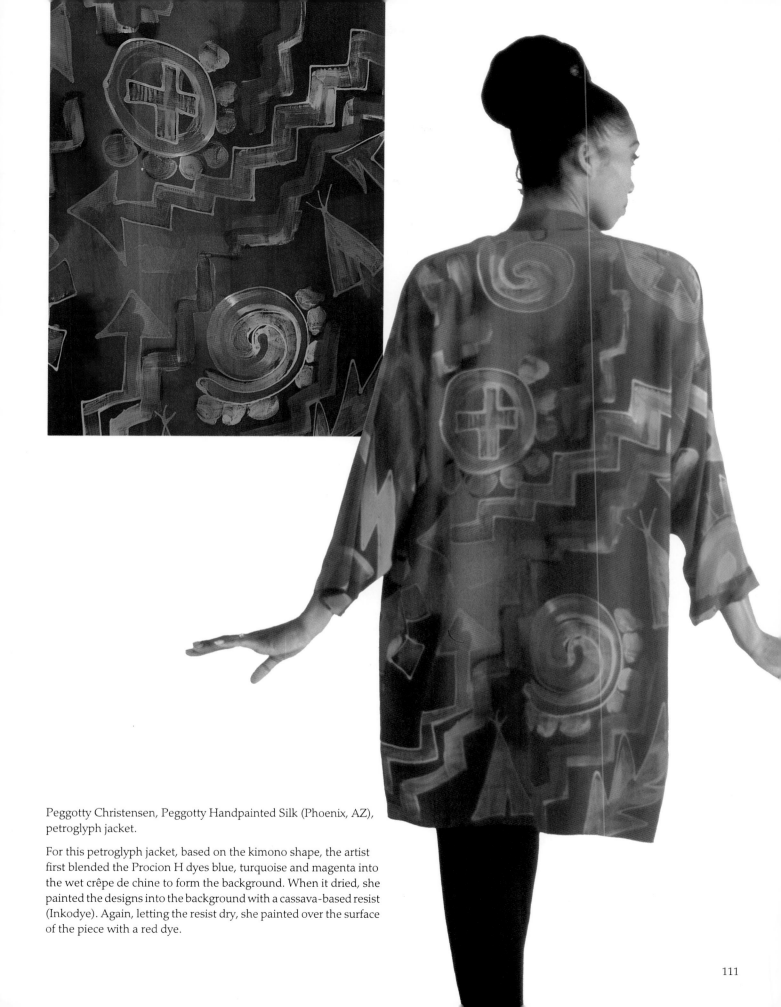

Peggotty Christensen, Peggotty Handpainted Silk (Phoenix, AZ), petroglyph jacket.

For this petroglyph jacket, based on the kimono shape, the artist first blended the Procion H dyes blue, turquoise and magenta into the wet crêpe de chine to form the background. When it dried, she painted the designs into the background with a cassava-based resist (Inkodye). Again, letting the resist dry, she painted over the surface of the piece with a red dye.

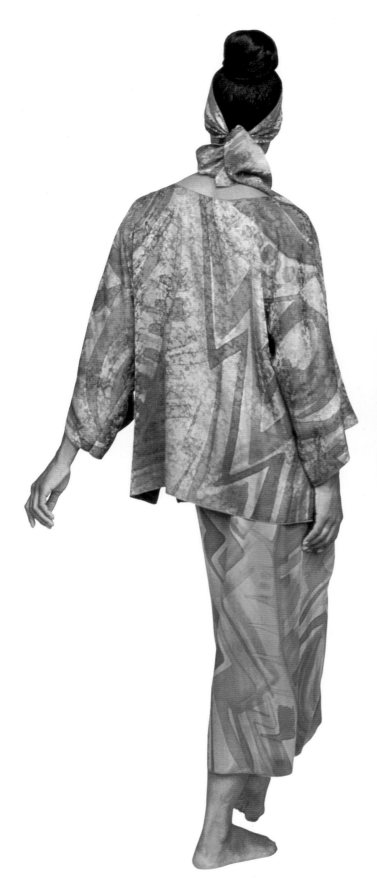

Peggotty Christensen, Peggotty Handpainted Silk (Phoenix, AZ) Jacquard tunic, crêpe de chine skirt.

The background was created wet-in-wet with taupe, magenta and brown Procion H dyes. She painted the navy blue designs into these wet colors with a foam brush cut into three sections. She then painted the dry background with sodium-alginate-thickened magenta and brown dyes.

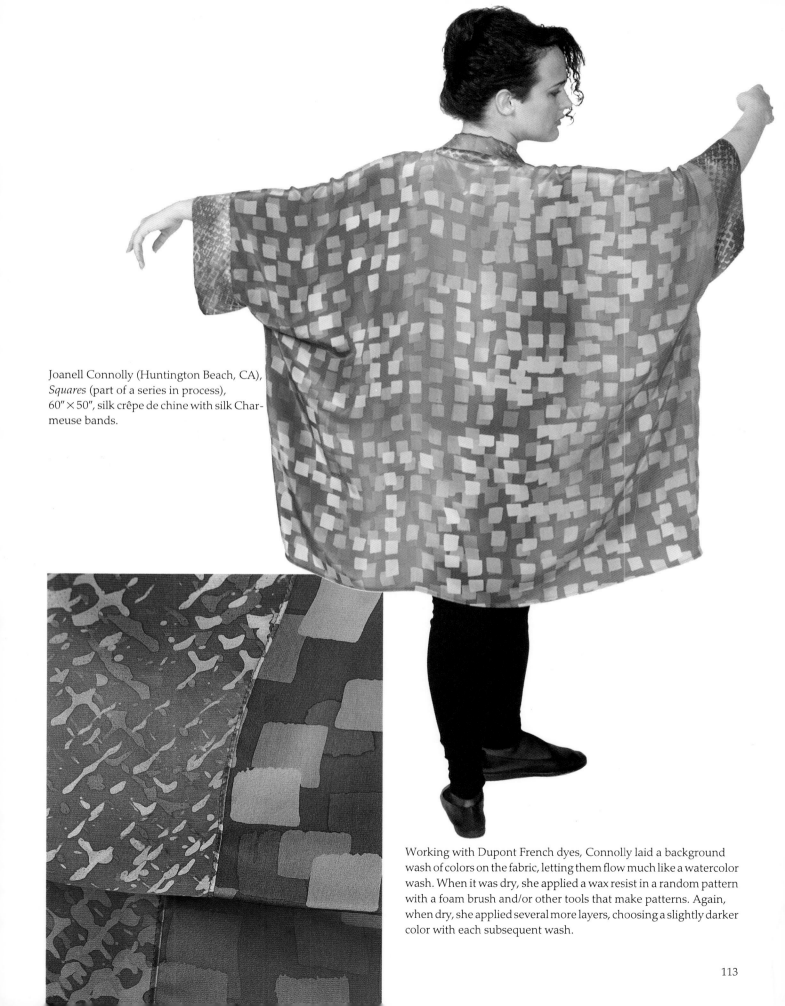

Joanell Connolly (Huntington Beach, CA),
Squares (part of a series in process),
60″ × 50″, silk crêpe de chine with silk Char-
meuse bands.

Working with Dupont French dyes, Connolly laid a background
wash of colors on the fabric, letting them flow much like a watercolor
wash. When it was dry, she applied a wax resist in a random pattern
with a foam brush and/or other tools that make patterns. Again,
when dry, she applied several more layers, choosing a slightly darker
color with each subsequent wash.

113

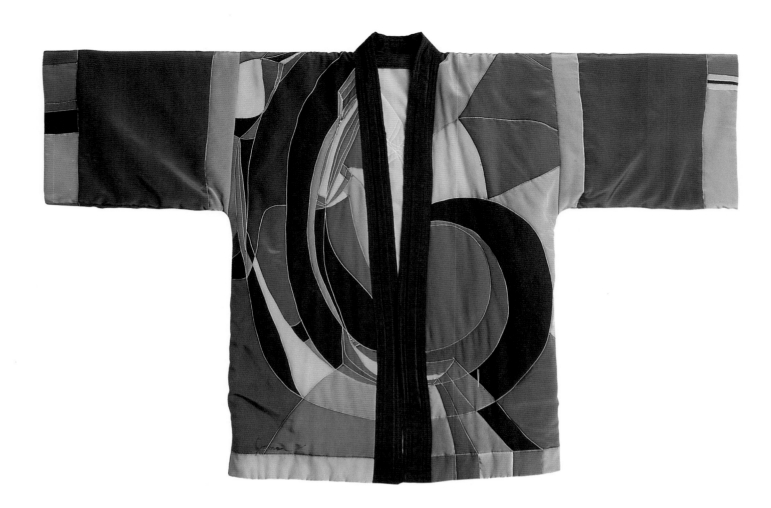

Jan Janas (Boulder, CO), *Basic Geo*, 12mm crêpe de chine jacket quilted along the gutta outline, yellow 8mm habotai lining, 34″ × 25″.

Working on unstretched silk, Janas drew the pattern of the kimono on the silk with pencil. She then stretched the silk onto a frame and went over the pencil lines with clear gutta resist. Next she painted into the resisted areas with strong, undiluted, Tinfix steam-set dyes in flat, complementary colors—purple, yellow and black—to create olive green (yellow plus black) and greenish brown (yellow with a little purple). The resulting juxtaposition of shapes and color was a study in contrasts: small versus large, angles versus curves, bright versus dull.

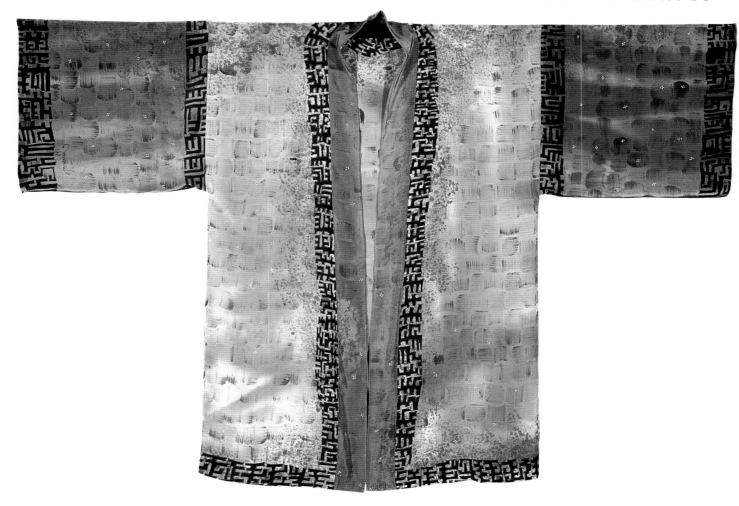

Jan Janas (Boulder, CO), *Fall Repeats*, unlined jacket of 12mm crêpe de chine, 34″×25″.

Janas penciled the kimono pattern onto stretched silk. Again working with complements—Tinfix steam-set dyes of greens, burgundy, gray and black—Janas loosely brushed on colors wet-in-wet with a 2-inch foam brush. When the silk was dry, she worked into the colors with black gutta resist, outlining the borders with a geometric maze design. Then she filled the resisted areas with black dye. With a fan brush, Janas drybrushed a basket weave pattern into the fabric, then with thickened burgundy dye, she sponged on textural effects over the basket weave near the maze to tie both patterns together. Finally she embellished the design by applying gold fabric paint in a small four-dot square repeat pattern.

Jan Janas (Boulder, CO), *Pink Squared*, sleeveless 12mm crêpe de chine kimono, dip-dyed rose shantung lining, 52″ × 22″.

Janas began by loosely defining the squares with a 1-inch foam brush, then adding calligraphic lines with a round brush and thickened VisionArt dye. She added the very fine linework around the squares with thickened dye in a metal-tipped applicator bottle. When the painting was dry, she immersed the fabric and lining in a bath of rose VisionArt dye.

KIMONOS WITH A JAPANESE LOOK

Artists in this section were inspired by the traditional Japanese kimono. John Marshall's painting evokes ancient Japanese paintings, symbols and woodcuts. He also used a Japanese process to paint the fabric. Diane Segal subtly includes many traditional Japanese ideas in her kimono, which she designed with a traditional Japanese obi or belt. The long sleeves have been left open and hanging at the armpit, as in traditional Japanese kimonos.

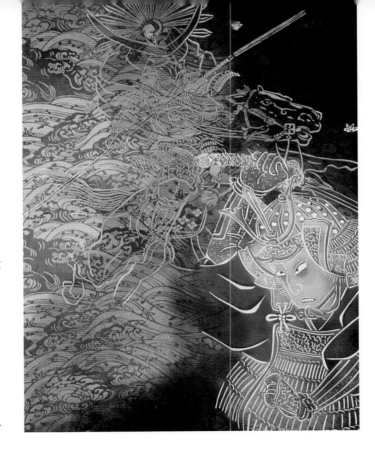

John Marshall, John Marshall: Works on Fabric (Oakland, CA), untitled, silk kimono.

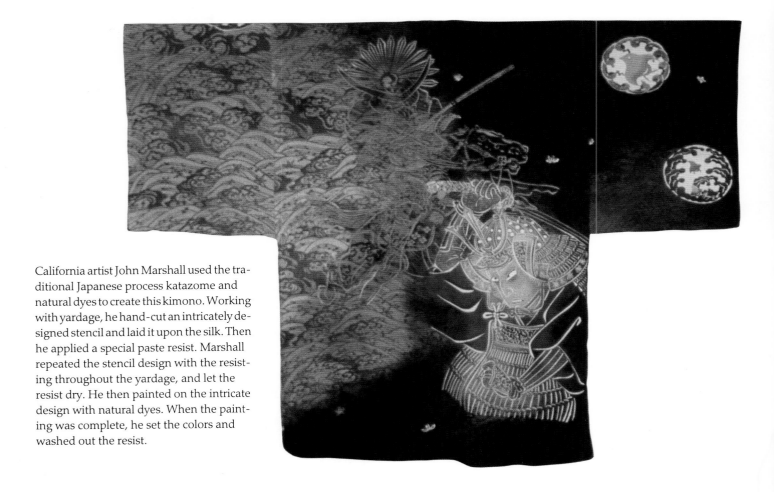

California artist John Marshall used the traditional Japanese process katazome and natural dyes to create this kimono. Working with yardage, he hand-cut an intricately designed stencil and laid it upon the silk. Then he applied a special paste resist. Marshall repeated the stencil design with the resisting throughout the yardage, and let the resist dry. He then painted on the intricate design with natural dyes. When the painting was complete, he set the colors and washed out the resist.

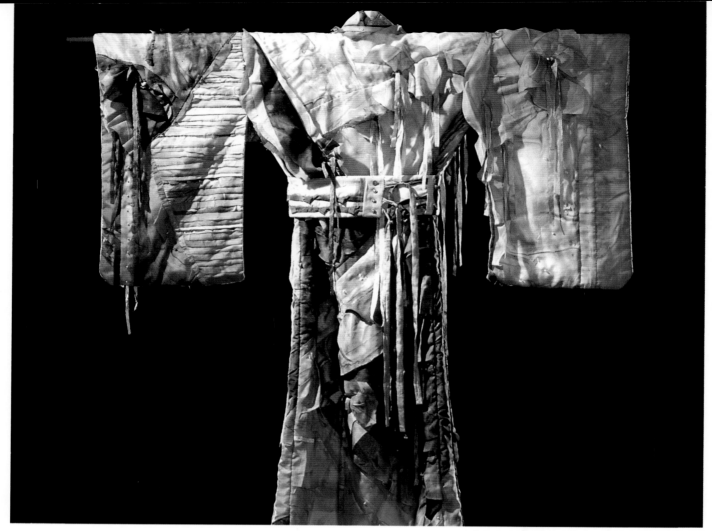

Diane Segal (Albany, NY), *Japonisme*, silk kimono, 53″ × 51″.

Segal began by laying five yards of silk fabric on a large, clear, plastic drop cloth. She then sprayed clean water on the silk to dampen it so she could work wet-in-wet. Next she mixed a tablespoon of silk paint with an equal amount of water and added a small amount of Createx opalescent fabric paint to the mixture to add a shimmer to the paint. She painted the wet silk with a wide assortment of brushes and marking tools for interesting effects. Where more intense color was desired, Segal applied concentrated Deka silk paint into areas of more diluted paint.

IMAGINATIVE AND WHIMSICAL TREATMENTS

The following artists have unleashed their imaginations and created some rather unusual treatments for the traditional kimono.

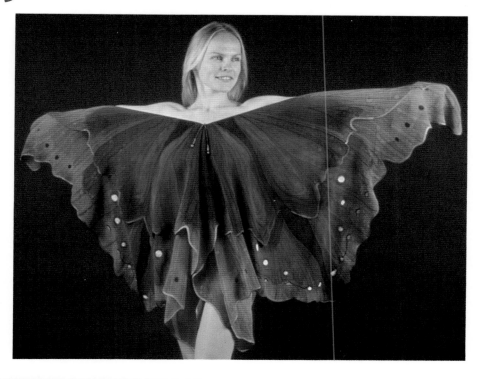

Judy Barnes Baker (Rancho Palos Verdes, CA), *Radiant Wings*, silk chiffon kimono, 56" × 36".

Using Dupont dyes and Deka textile paints, Baker painted and sprayed the colors on stretched silk, then manipulated the wet paint with brushstrokes of dye and alcohol using a Chinese calligraphy brush. After drying and steam setting, the fabric was embellished and highlighted with Deka textile paints.

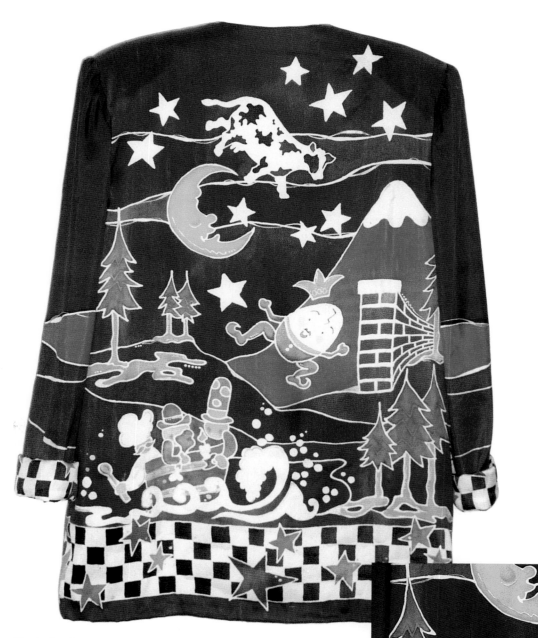

Hattie Sanderson, Aunt Hattie's Treasure Box (Clare, IL), *Nursery Rhymes*, 19mm silk Dupion kimono.

Sanderson outlined the main lines of these whimsical nursery rhyme characters with gutta resist. The main characters were painted wet-in-wet within the resisted lines to give them depth. She then filled in the outer edges of those characters with a wide line of gutta to protect them from the accidental bleeding of background color. The trees were first painted light green, then branches were outlined in gutta, and then blues and greens were brushed in to create texture. The white of the fabric was used as a strong design element. After steam setting and dry-cleaning the fabric, gold paint was used to enhance the design.

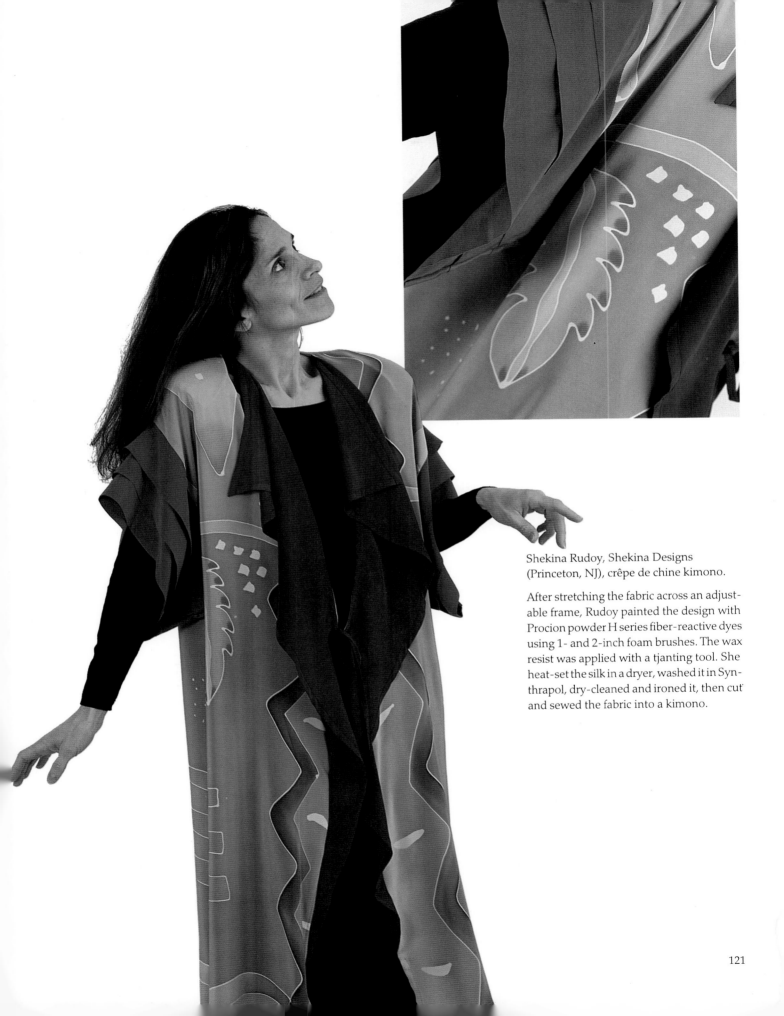

Shekina Rudoy, Shekina Designs
(Princeton, NJ), crêpe de chine kimono.

After stretching the fabric across an adjust-
able frame, Rudoy painted the design with
Procion powder H series fiber-reactive dyes
using 1- and 2-inch foam brushes. The wax
resist was applied with a tjanting tool. She
heat-set the silk in a dryer, washed it in Syn-
thrapol, dry-cleaned and ironed it, then cut
and sewed the fabric into a kimono.

121

NATURAL AND FIGURATIVE DESIGNS

In this group of kimonos, the artists have been inspired by nature—trees and flowers, woodlands, the seasons and other outdoor subjects, including people. Some examples are representational, others abstract, still others are nonobjective and textural. We hope these examples encourage you to seek ideas and effects from nature.

Wirasekara first outlined the basic design in cold wax resist. She then painted the design and background using liquid Procion H silk dyes. When it was dry, she set the dyes by steaming the silk, then washed the garment to get rid of the excess dyes. She picked out and highlighted areas with fabric paints and pens, first with colors darker than the dyes, then with metallic and light colors.

Sharmini U. Wirasekara (North Vancouver, British Columbia, Canada), *Rainforest*, hand-painted crêpe de chine silk short coat, 35" × 44".

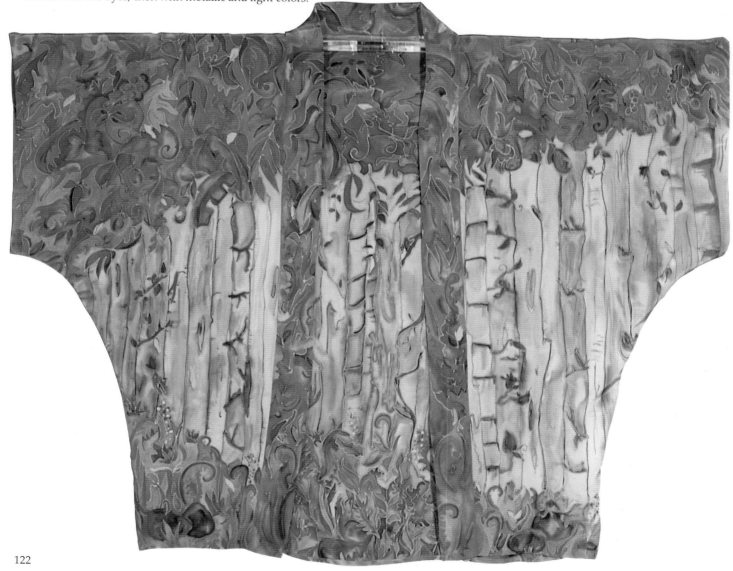

Judith Spector (Santa Monica, CA), *Ode to Spring,* 26" × 38".

To achieve the Monet-like effect of spring coloration, Spector knitted three different shades of silk bias ribbons (created by Hanah Silk of Los Angeles) using stockinette and garter stitch made with No. 11 needles. For the neckband, Spector switched to a garter stitch, knitted on the diagonal with no. 11 needles. Every 1½ yards, Spector cut and joined the ribbon at the seams. About 6'' from the front edges, she interspersed the stockinette stitch with woven strips of ribbon to show the ribbon in its flat state, adding another dimension to the garment. The ends of the woven strands were left loose at the top and bottom and tied, adding grace and movement to the garment.

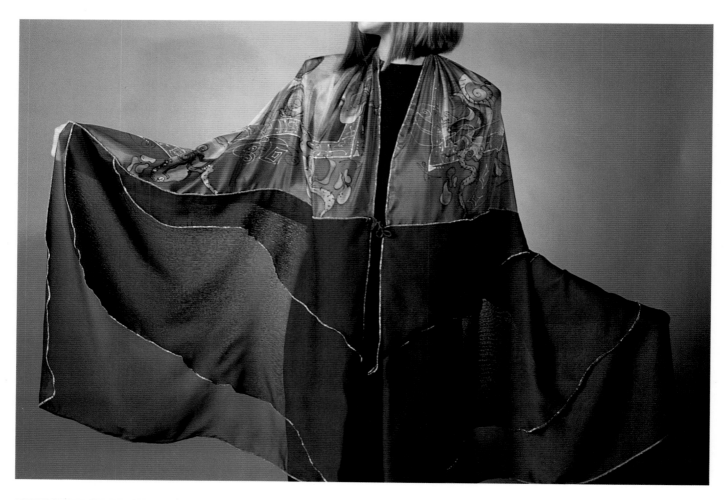

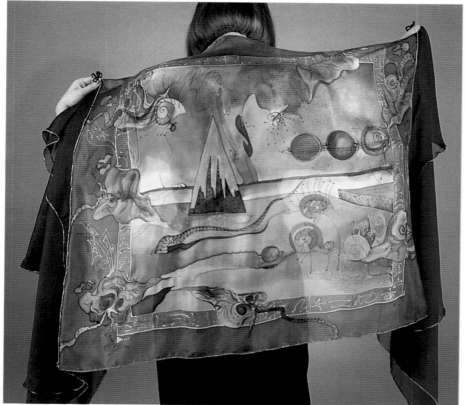

Barbara Tiberio-Danko (Albertis, PA) "Oneiric Fields," 8mm silk pongee and chiffon shawl, front and back, 78″ × 30″.

For this silk pongee and chiffon shawl, Tiberio-Danko painted a surrealistic landscape full of personal icons. She began by drawing the images with Silktint Permanent Black Gutta and clear resist. Next she painted the inside areas with Tinfix dyes applied with a squirrel-hair brush. Then she threw on sea salt while the dye was still wet for a textured effect. After steam-setting the dyes, she sewed the edges of the triple-layered chiffon shawl on a serger using purple and a multicolored metallic thread.

Jan Janas (Boulder, CO), *Winter Mist*, 12mm crêpe de chine lined jacket, 34″ × 25″.

To get a pebbled texture on the silk, Janas ironed the yardage over crumpled wax paper to create a random, textured resist. Then she stretched the silk and with a 2-inch foam brush, quickly brushed on grays, blues, turquoises and violets of VisionArt dyes, working wet-in-wet. Lastly, she dip-dyed the lining in one of the colors in the jacket, a blue-gray.

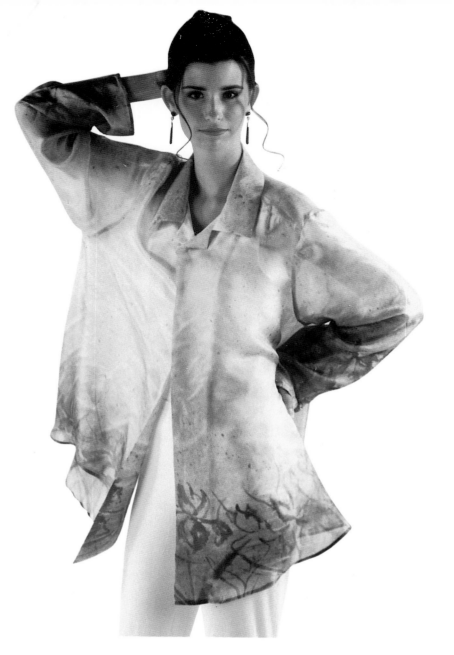

Suzanne Wegener (Westmont, IL), *Spring Fling,* 5mm china silk loose-fitting blouse. Designer: Debbie Little.

Wegener sprayed the background with a light turquoise blue dye over a stencil of an iris with leaves. This design was repeated many times. The fabric was dried and then placed on a piece of plastic, and the irises were painted directly on the fabric with VisionArt dyes diluted to a soft pastel shade. The plastic underneath caused the dye to puddle, adding an interesting texture not unlike batik.

Suzanne Wegner, *Spring Fling* (detail).

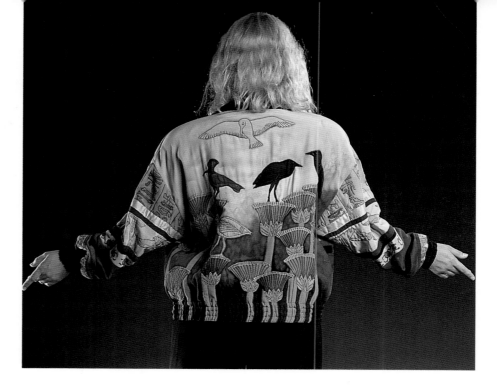

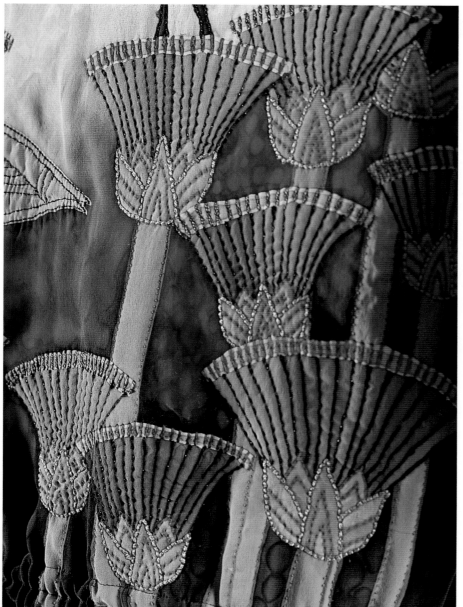

Patricia Hable Zastrow (Sun Prairie, WI), *On the Nile*, crêpe back silk kimono jacket, china silk lining.

Zastrow prepares large amounts of primary-color resists, which she stores in a cool, dark place for up to a year. She then blends these colored resists into muted colors that form the basic color schemes of her garments. In making this jacket, Zastrow dyed the silk pieces in Procion dye. While the background colors were still damp, and with a brush, Zastrow spotted the black areas with yellow and the red areas with black for a mottled effect. When dry, the silk pieces were filled with polyester fiberfill and hand-quilted using metallic thread.

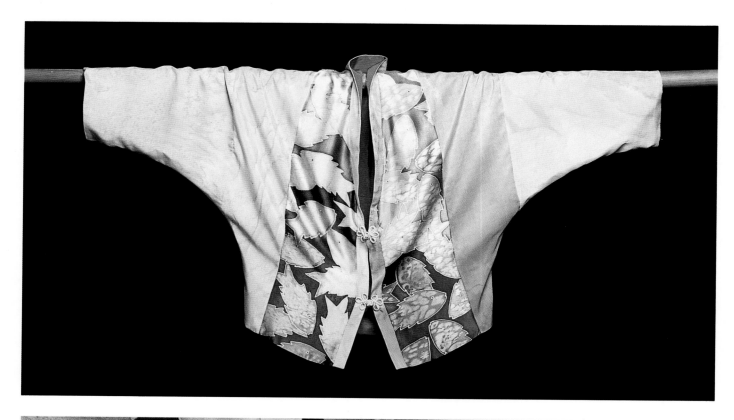

Kathleen Owens (Lafayette, LA), *Fish Jacket*, pieced silk Charmeuse and silk tussah jacket.

Owens painted this silk kimono jacket with Dupont and Tinfix French dyes outlined with gutta resist. The textural effect within the fish was done by salting while the dye was still wet.

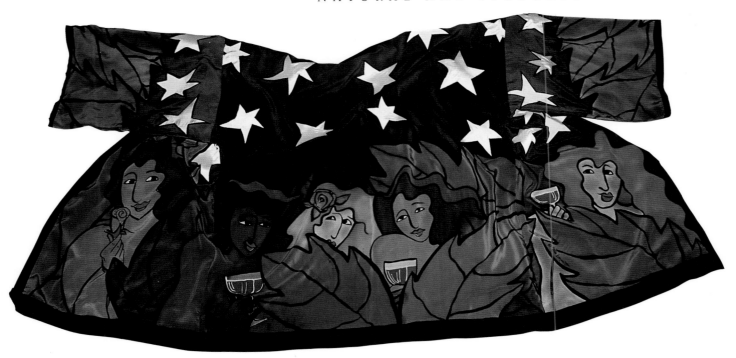

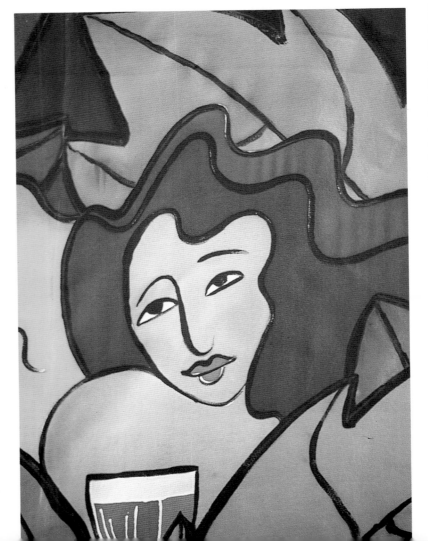

Marybeth Boyanton, Emlié Soie Handpainted Silk (Knoxville, TN), *Les Soeurs: Soirée à Soie*, crêpe de chine kimono.

The design was outlined with water-based resist made from black dye thickened with sodium alginate. (You can't use black or clear gutta for this step because the painted outline is marred when the piece is dry-cleaned.) The wine-colored background was painted and dried thoroughly. The fabric was steamed, dried and restretched. Outlines were repainted with clear gutta, after which Boyanton dampens the upper part of the sky with water where the color is to be lighter before adding blue to the lower part to develop the sky. The fabric was stabilized with Stitch-n-Tear so it would withstand the satin stitching of the appliqué stars.

129

More Great Books
for Creating Beautiful Crafts!

The Complete Book of Silk Painting—Create fabulous fabric art—everything from clothing to pillows to wall hangings. You'll learn every aspect of silk painting in this step-by-step guide, including setting up a workspace, necessary materials and fabrics, and specific silk painting techniques. #30362/$26.99/128 pages/color throughout

Everything You Ever Wanted to Know About Fabric Painting—Discover how to create beautiful fabrics! You'll learn how to set up work space, choose materials, plus the ins and outs of tie-dye, screen printing, woodgraining, marbling, cyanotype and more! #30625/$19.99/128 pages/color throughout/paperback

Master Strokes—Master the techniques of decorative painting with this comprehensive guide! Learn to use decorative paint finishes on everything from small objects and furniture to walls and floors, including dozens of step-by-step demonstrations and numerous techniques. #30347/$29.99/160 pages/400 color illus.

Master Works—Discover how to use creative paint finishes to enhance and excite the "total look" of your home. This step-by-step guide contains dozens of exciting ideas on fresco, marbling, paneling and other simple paint techniques for bringing new life to any space. Plus, you'll also find innovative uses for fabrics, screens and blinds. #30626/$29.95/176 pages/ 150 color illus.

Creative Paint Finishes for the Home—A complete, full-color step-by-step guide to decorating floors, walls and furniture—including how to use the tools, master the techniques and develop ideas. #30426/$27.99/144 pages/212 color illus.

The Crafts Supply Sourcebook—Turn here to find the materials you need—from specialty tools and the hardest-to-find accessories, to clays, doll parts, patterns, quilting machines, and hundreds of other items! Listings organized by area of interest make it quick and easy! #70253/$16.99/288 pages/25 b&w illus./paperback

Stencil Source Book—Transform a room from plain to remarkable. This guide combines inspiration with practical information—and more than 180 original designs you can turn into stencils. #30595/$22.95/144 pages/150 color illus.

Painting Murals—Learn through eight step-by-step projects how to choose a subject for a mural, select colors that will create the desired effects, and transfer the design to the final surface. #30081/$29.99/168 pages/125 color illus.

Fabric Sculpture: The Step-By-Step Guide & Showcase—Discover how to transform fabrics into 3-dimensional images. Seven professional fabric sculptors demonstrate projects that illustrate their unique approaches and methods for creating images from fabric. The techniques—covered in easy, step-by-step illustration and instruction—include quilting, thread work, ap-

plique and soft sculpture. #30687/$29.99/160 pages/300+ color illus.

Decorative Wreaths & Garlands—Discover stylish, yet simple to make wreaths and garlands. These twenty original designs use fabrics and fresh and dried flowers to add color and personality to any room, and charm to special occasions. Clear instructions are accompanied by step-by-step photographs to ensure that you create a perfect display every time. #30696/ $19.99/96 pages/175 color illus./paperback

The Complete Flower Arranging Book—An attractive, up-to-date guide to creating more than 100 beautiful arrangements with fresh and dried flowers, illustrated with step-by-step demonstrations. #30405/$24.95/192 pages/300+ color illus.

The Complete Flower Craft Book—Discover techniques for drying fresh flowers and seedheads, creating arrangements to suit all seasons and occasions, making silk flowers, potpourri, bath oil and more! This guide is packed with photographs, tips, and step-by-step instructions to give you a bouquet of ideas and inspiration! #30589/$24.95/144 pages/275 color illus.

Jewelry & Accessories: Beautiful Designs to Make and Wear—Discover how to make unique jewelry out of papier meche, wood, leather, cloth and metals. You'll learn how to create: a hand-painted wooden brooch, a silk-painted hair slide, a paper and copper necklace, and much more! Fully illustrated with step-by-step instructions. #30680/$16.99/128 pages/150 color illus./paperback

Paint Craft—Discover great ideas for enhancing your home, wardrobe, and personal items. You'll see how to master the basics of mixing and planning colors, how to print with screen and linoleum to create your own stationery, how to enhance old glassware and pottery pieces with unique patterns and motifs, and much more! #30678/$16.99/144 pages/200 color illus./paperback

Nature Craft—Dozens of step-by-step nature craft projects to create, including dried flower garlands, baskets, corn dollies, potpourri and more. Bring the outdoors inside with these won-

derful projects crafted with readily available natural materials. #30531/$14.95/144 pages/ 200 color illus./paperback

Paper Craft—Dozens of step-by-step paper craft projects to make, including greeting cards, boxes and desk sets, jewelry and pleated paper blinds. If you have ever worked with or wanted to work with paper you'll enjoy these attractive, fun-to-make projects. #30530/$16.95/144 pages/ 200 color illus./paperback

The Christmas Lover's Handbook—Everything you need to plan and create a fabulous Christmas season. You'll find specific ideas for getting yourself and those around you in the holiday spirit. Plus, you'll find festive ideas for planning everything, from selecting or making cards to gift wrapping with imagination. #70221/$14.95/256 pages/170 b&w illus./paperback

The Art of Painting Animals on Rocks—Discover how a dash of paint can turn humble stones into charming "pet rocks." This hands-on easy-to-follow book offers a menagerie of fun—and potentially profitable—stone animal projects. Eleven examples, complete with material list, photos of the finished piece, and patterns will help you create a forest of fawns, rabbits, foxes, and other adorable critters. #30606/$21.99/144 pages/250 color illus./paperback

Decorative Boxes To Create, Give and Keep—Craft beautiful boxes using techniques including embroidery, stencilling, lacquering, gilding, shellwork, decoupage and many others. Step-by-step instructions and photographs detail every project. #30638/$15.95/128 pages/color throughout/paperback

Elegant Ribboncraft—Over 40 ideas for exquisite ribbon-craft—hand-tied bows, floral garlands, ribbon embroidery and more. Various techniques are employed—including folding, pleating, plaiting, weaving, embroidery, patchwork, quilting, applique and decoupage. All projects are complete with step-by-step instructions and photographs. #30697/$16.99/128 pages/130+ color illus./paperback